Painters'Wild Workshop

QUARRY

First published in the United States of America by:
Quarry Books, an imprint of Rockport Publishers, Inc.
33 Commercial Street
Gloucester, Massachusetts 01930-5089
Telephone: (978) 282-9590
Fax: (978) 283-2742
www.rockpub.com

ISBN 1-56496-434-5

10 9 8 7 6 5 4 3

Designer: The Design Company

Printed in China.

Cover credits:

top row:
(*left*) Masterfield, page 48
(*middle*) Newdoll, page 102
(*right*) Beam, page 42

middle row:
(*left*) Fernandez, page 92
(*middle*) Edwards, page 37
(*right*) Machicado, page 97

bottom row:
(*left*) Osborn Dunkle, page 64
(*right*) Cadillac, page 55

Painters' Wild Workshop

GLOUCESTER MASSACHUSETTS

QUARRY BOOKS

12 master artists help expand your creativity

Lynn Leon Loscutoff

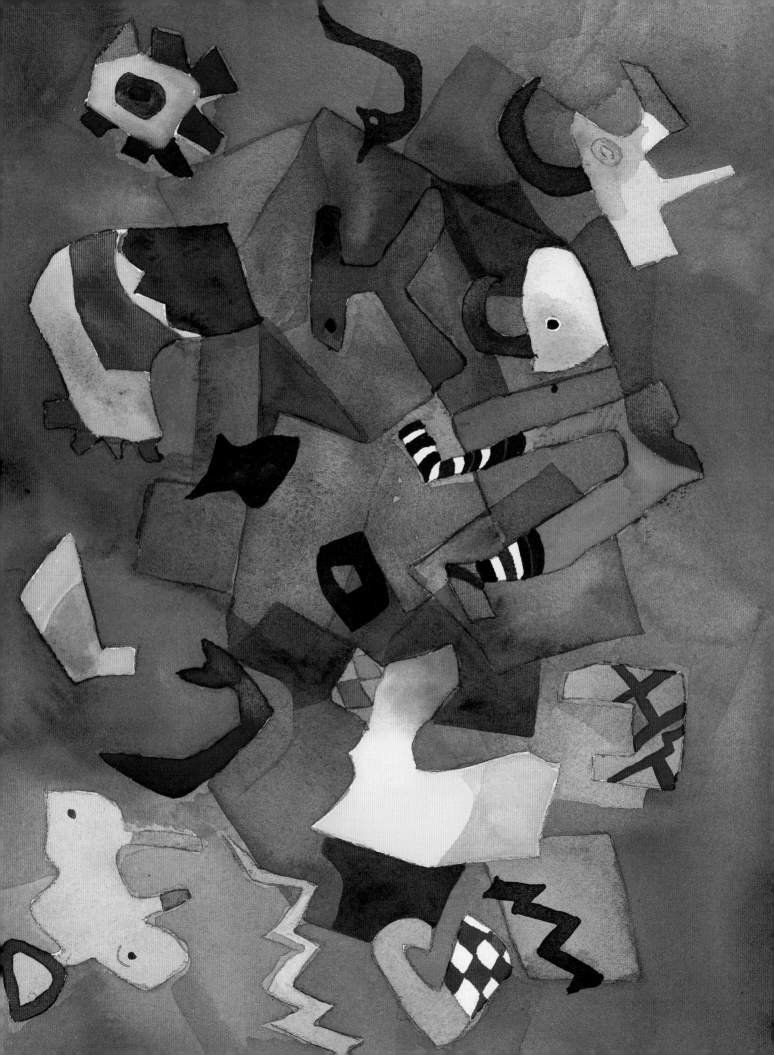

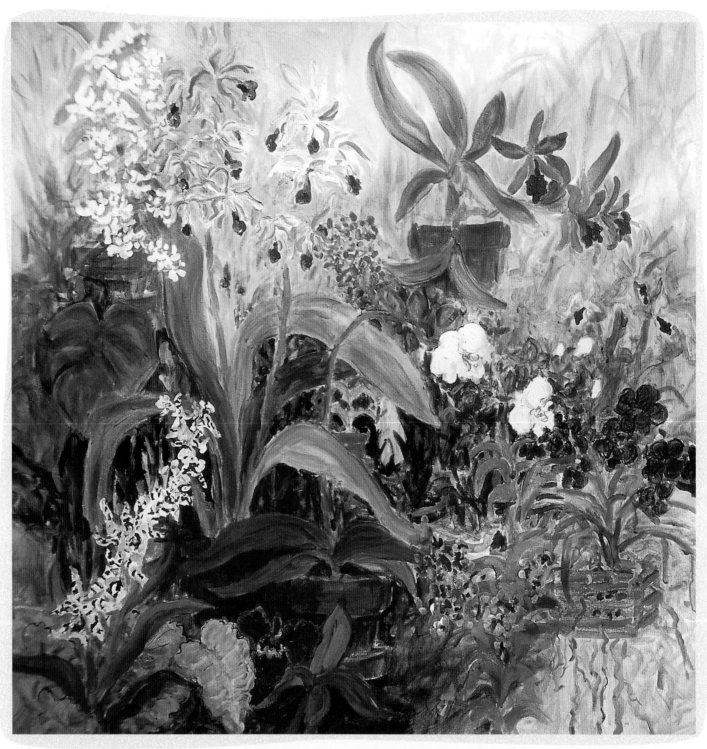

Falling in Love with Orchids
acrylic
40" x 48"
(101 cms x 122 cms)
Lynn Loscutoff

"Releasing your artistic self gives rise to a life of pleasure and struggle–as you use art to create your own reality. Painters are philosophers, psychologists, mathematicians, chemists, scientists, and poets."

–Lynn Leon Loscutoff

Contents

Any way you look at it, we can become the enlightened artists we have the right to be.

Introduction

My goal to excite my fellow artists to stretch, explore, expand, exploit, and experiment has been reinforced. The more I visited, interviewed, observed, and discussed fresh perspectives with the artists you will meet in these workshops, the more energized I have become in my own work. In this quest I inspired myself and I hope to inspire you.

Each artist brings a unique perspective to the easel. Diversity of personalities, motivations, styles, and techniques unfurl through these pages.

Wild workshops range from abstract to traditional. From on-site demonstrations to workshops in progress. Sessions give fresh insights into exploring with media—from aqua media to oil painting, to printmaking, to visual word expressions, collage, layering, and computer enhancement. Every contributing artist has given unselfishly of their knowledge and richly deserves appreciation. I share with them a sincere wish that this book will serve to encourage your spirit of adventure into new experiences and techniques.

How can we not be challenged? Risks are what we do as artists, every time we take up a brush. Every artist that has contributed to this book and every artist I have ever known and admired has given so much to me. Every act of creativity that we observe or that we participate in is such a blessing. We expand with our inventory of thoughts and ideas.

My wish for you is that your metamorphoses be many and that your artistic journey be wildly creative.

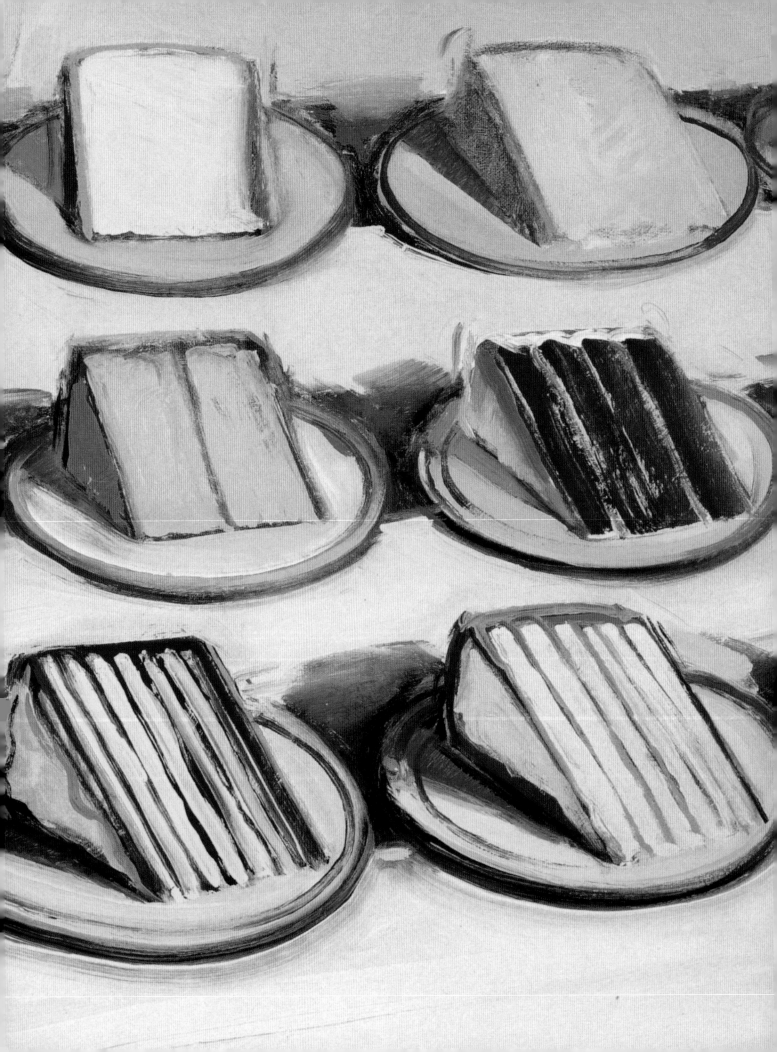

Cake Slices
Wayne Thiebaud
oil on canvas

Sunlight, Front Lit, Back Light, Reflections, Values, Hues, Refraction, Halation, Symbols, Patterns, Tension, Gesture, Line, Drawing, Push-Pull, Journal, Painting, Night Painting, Distorting, Elongating, Widening, Collage, Complementing, Balancing, Structuring, Packing, Aspiring

Explore

Challenge Your Creative Repertoire

I will paint my dreams.

Every day of my life will be creative, joyful and full of love...

lighten up artists — we like to play it arouses the genius in us!

I hope to seduce you to experience a wild workshop, and to inspire you to experiment joyfully, with abandon. Join us and soar on a quest to stretch your artistic will, to paint images real and imagined—to expand **artistic** experiences. The challenge is to increase your knowledge of methods, materials, techniques, and possibilities and to dare you to reach beyond what is known and familiar to you. Experimenting can nurture and create a force to spur us on to new life, visions, energies, and directions: it frees us to continue taking steps, progressing, resolving, trying, and growing. Why draw the line on your creative potential? Experimenting challenges, stimulates, and expands a creative repertoire. Blessed is the artistic essence in all of us. **Enrich**, energize, and love your artistic self. **Who and where are you in your art?** Are you where you want to be? Do you feel your best work is the one you will create tomorrow? We choose many lessons in life. Continued learning stimulates our creative spirit and our artful souls. Never be afraid to **trust** your own instincts, **illusions**, fantasies, visions, or dreams.

Are you using all of your personal resources? Left brain, right brain, conscious or subconscious, we enjoy the miracle of thinking, problem solving, concentrating, conceptualizing, and inventing. Scientists are still trying to understand how the brain and mind function. Have you ever painted and then realized that you: skipped lunch, stood for hours, and missed a special date? Were you in an altered or Alpha state of consciousness? **Was your subconscious directing the tools in your hand?** What a privileged group we are to have the ability to move in and out of a **blissful** state at will and call it working. Many of the most talented artists are unable to describe their process as they work. **In dreams,** symbols often represent our thoughts. They have played a significant role in art as communication and language from the first scratchings and drawings made by our distant ancestors. Let's begin experimenting with the symbolic circle and go on from there. Where? Around and around and everywhere. **WE invite you to explore** your natural creativity and we encourage you to parlay **your potential.**

Change your direction!

Did the apple hit Isaac Newton on the head as it fell from the tree? New thoughts can be like that you know, and less painful…

I give myself permission to experiment!

An affirmation is a pep talk I give myself—

Light

I will love light and my amazing eyes.

Shine different lights on a blank canvas to create the environment you require at a specific time.

Aristotle believed that light travels in waves.

Every sunrise is yours.
Wavelengths from the sun are different lengths and colors.
Every sunrise is a new day dawning for your creativity.

You are the brightest star.

Become a sun worshiper.

Become illuminated!

I am light years beyond in my art.

Illuminate Your Inspiration. You must study light to really understand what it can do in your paintings. Light powers a painting. Wavelengths give us color and stimulate our thought processes, our emotional reactions, our vitality. Surfaces reflect light. Planes reflect light. We study light and yet we know that light is rarely seen. Its presence is made known by the surfaces upon which it shines. High surface brightness is associated with intense light; low surface brightness with dim light.

Luminosity can be achieved with layers of glazes. Even more light can be bounced by painting over a watercolor or an acrylic painting with a clear polymer acrylic coat of spray. A glaze of clear varnish can give more reflected light to a well-dried oil painting.

White. Treasure white light, white paper, white canvas, and white paint. White gives painters the power of luminosity. Place your darkest dark against your lightest light and invite immediate attention. Touches of aureolin yellow or painted sunlight throughout a landscape will add balance and tie a painting together.

Light is our lifeline and we must continue to know it and to value it. Meet every new sunrise as the most important part of your day. Examine the light at each time of day—morning, noon, and dusk—for energized reflections and moods. Light fuels your body, spirit, and soul.

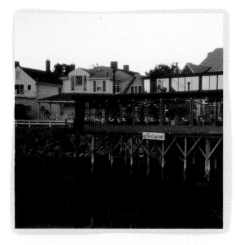

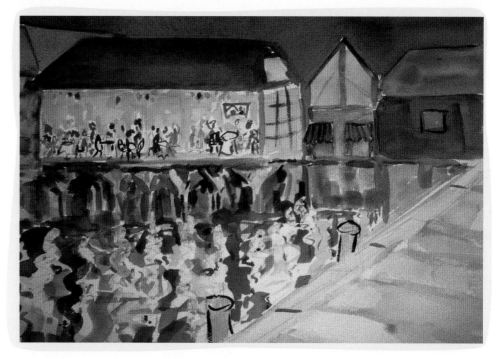

A seaside restaurant, with its pilings and people enjoying the evening, is a perfect subject for painting reflections of light. The scene is lively. This is what I hope you will find when you go exploring for light: another way of seeing it.

Warm colors—orange, cadmium yellow, cobalt violet—dropped into the cool colors of ultra marine blue, Persian blue and Terre Verte build the illusion of dark water and moonlight in this night painting.

morning

Give yourself an early morning gift of light.

Awaken at sunrise and watch the velvet blue sky become streaked with a pink and golden glow. Plan a painting illustrating the difference in reflections of light. Visit your chosen site just before twilight, to make sure that the scene remains interesting in the late part of the day. Why? Because it takes light, even artificial light, to make contrasts, exciting reflections, and interesting light bounces.

To begin a painting of light reflections, try using colorless art-masking fluid. This unpigmented fluid forms a protective coating on the paper to save the whites. Sketch quickly and capture the large shapes, then wait for the masking fluid to dry. When painting reflections or broad washes, masking allows you more freedom. Dash in Hansa yellow for interior light and add arbitrary shadows. Paint with complete freedom and be daring.

Paint outside to capture light. John Constable and J. M. W. Turner were considered "daring" in the early nineteenth century when they became plein air painters and went out of the studio and painted light.

evening

Study the patterns that are all around you, made by light and shadow. In the picture below, a tree casts a shadow, diffusing the sunlight and creating an abstract pattern. Notice the difference between the interior light and the high key light outside. Such a dappling effect of light could be less inviting or more mysterious. Dappled sunlight is interesting and is a good place to drop complements of warm and cool to set up vibrations. Examine the atmosphere in the skies as well as in interiors for correct light interpretation: Each cloud, each sunset, and each shadow is different. An overcast day might require pink underpainting, whereas yellow underpainting for a sunny day can give a subtle glow.

Every method has merit and should be explored. Follow in the footsteps of the painter Raoul Dufy, who said, "I don't follow any system. All the laws you can lay down are only so many props to be cast aside when the moment of creation arrives."

Warm light with cool blue and green shadows.

Cool light with warm red, purple, and orange shadows.

An all-over light source gives us flat space. Matisse used this technique. It is a favorite style of mine.

Shadow gives us the magic of creating mysterious illusions. Light and shadow make three dimensions on a two-dimensional surface. Light creates space, form, depth, planes, reflections and images. Shadows tell the story as well as light: the time of day, weather, season. They create moods, suggest form, intensify shapes, create vibration. Try mixing warm and cool colors to create vibrating shadow. After Van Gogh painted *Starry Night*, he suggested the painting "might give somebody else the idea of doing night effects better than I did. I tried to express through red and green the terrible passions of humanity." Van Gogh knew the "value" of shadows. Therein lies your challenge. Do you?

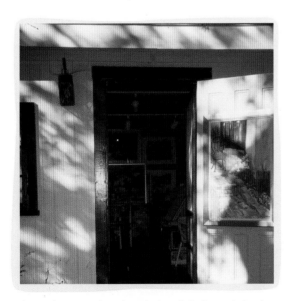

The author's studio, dappled with light and shadow.

Color

When I face my next blank canvas, I will ignore a monochromatic mood and splatter analogous colors.

"We shall set down white for the representative of white light, without which no color can be seen: yellow for the earth; blue for the air; red for fire, and black for total darkness." Leonardo da Vinci (1452-1519)

Color yourself a new palette.

One good complement deserves another.

Push-Pull: The closer together two colors of equal value are, the less the pull. The further apart two similar colors of equal value are, the greater the pull.

Nothing is visible without color.

Sometimes colors you don't like become your best friends.

The most sensuous part of painting is playing with color.

Colors are ideas expressing themselves. Light is essential to see color.

Color is essential to see form. Without color it would not be possible for

artists to create flat space, depth, perspective, planes, or values. Second to

light, color is the most important element in your life. Use red for energy.

Calm yourself with blue. Color your thinking. Get to know your personal

rainbow. Give yourself space. Alter your perspective. Are your contours

illuminated? Does your surface have tension? Are you expanding your

horizons? Try redesigning your pattern. Add vibration to your creative life.

Be arbitrary with your color.

You are full spectrum. Color excites, nourishes, feeds human dimen-

sions inside and out, and paints your fantasies. Color is our perception of

defined wavelengths of light. Color profoundly affects our lives. Color, into

the twenty-first century, has greater impact and significance than in all of

past recorded time. Modern technology, advances in the sciences, extended

studies into psychology, and other multidisciplinary considerations create

a vast foundation for artists to create imaginative and inventive works. The

bridging of beauty and science can only expand our palettes.

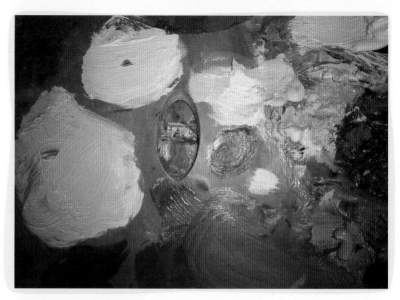

Rachael Kennedy's palette

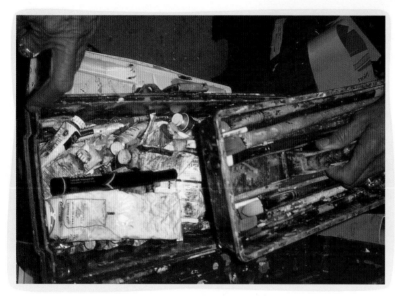

Paint box of implements

Your palette is limitless; your choices can satisfy your total personality. Color affects you inside and out. If you have the urge to concoct outrageous color schemes, do it. It might be just what the doctor ordered.

Abandon yourself to color. Blend it. Smudge it. Overlap it. Scumble it. Having said all of this, the basic reality is that you will probably always paint the light and color as it was where you grew up. If you examine how contemporary painters evolve, you will note that after reaching the most technically accurate realism, continued growth is most often to simplification. So think as a child. Paint as child. Enjoy the process as a child.

The Theory Behind Push/Pull

Hans Hoffman (1904–1966), a brilliant painter, author, and lecturer, left a legacy of manipulating space with color he called "push pull." "Determining space is multi-sensory," he said. He constantly took part in revolutionary change. Hoffman attached the word "plastic" to the transference of a three-dimensional experience to two dimensions. He believed plastic creation is based on dualism of flatness and depth, as in the works of Matisse and Cézanne. "That which lies deep in space as form," said Hoffman, "must, by means of the advancing power of color oscillations, be brought forward again into the two dimensional poised quality of formal creation, and that which lies as form in the first plane of space, must be brought to expression by means of the heaviness-effect of color, so that the balance of the picture plane is not destroyed."

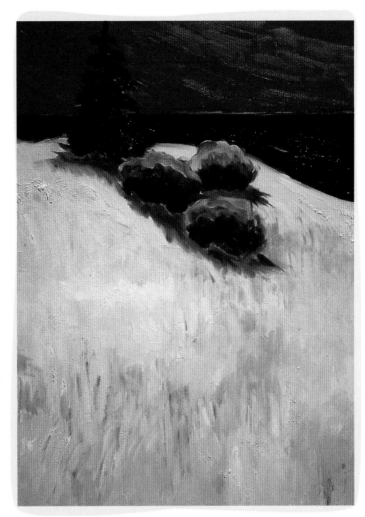

Three Bushes and a Tree
24" x 36"
(61 cms x 91 cms)

Try beginning a painting with a cadmium red line. The line will show through and add vibration to the forms.

Color Mixing with Rachael Kennedy

Experiment with outrageous color combinations and follow the lead of painter Rachael Kennedy, who admits to peeking into new tubes of paint to see if the colors will truly suit her high-key attitude. Explore every shade of green available and use them with verve. Try mixing a little yellow ochre with any green out of the tube and adding a touch of cobalt violet. Render sand on the beach with Naples yellow or yellow ochre with a little cobalt violet along the sand line. Alizarin crimson, cadmium yellow, and lots of white keep colors fresh and warm.

Line

I fall for a good line every time.

Relationships are the most important element.

Make a line on a surface and it is a creative act. Cross these two lines and you have the eternal symbol for creation. The angle of two crossed lines represents a magnitude of ideas from different civilizations, cultures, and religions.

Thirty centuries separate the signs on the right from the signs on the left.

In 2,000 B.C. parallel lines meant friendship.

Golden Ratio

Can we visually communicate in language or in art without line?

Converging lines give us perspective.

Air , octahedron.

Earth, cube.

Fire, tetrahedron.

The universe, dodecahedron.

Water, icosahedron

Line connects, separates, defines, outlines. Line thickness shows coming forward, moving away. Line up your enthusiasm. Lines define the earliest thoughts, ideas, symbols, pictograms, glyphs, ideograms and drawings. The Ancient Greeks thought that line was "golden" or divine. Extend your parameters concerning the traditional concepts of drawing. Does your line express where you want to go? Using pencil, charcoal, paint or laptop, this line of thought can take us beyond where we are. Redefine your boundaries. Cross over the line.

In drawing, line exercises control over our visual image. Line gives us order. Euclid's Elements, written around 350 BC gave us the "Golden Ratio." The golden ratio ($x + 1$ over x equals x over 1) is a line divided into two pieces so that the ratio of the whole line to the longer piece equals the ratio of the longer piece to the shorter piece. This mathematical pattern is purported to be the ideal proportion for the sides of a rectangle that the eye finds the most pleasing.

Cultivate your natural talents. Dare to cross the line. Create gesture. Lines in language give us words to express ourselves. Make an unending line tell a story. Encircle your thoughts. Take the line off the edge of the page and suggest that there is more to the drawing or painting than meets the eye. Let the viewer decide the rest of the story.

Line gives us geometry. Plato's interest was in knowing the permanent form of thought. Using geometric shapes, Plato conjured up what he felt were the four elements that made up the world. At right, Plato's Atomic Theory:

Perspective

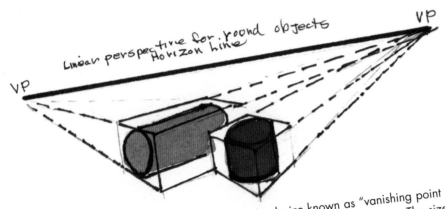

Linear perspective for round objects
Horizon line

We can look at two cylinders using the device known as "vanishing point perspective," a mathematical system determining how to size objects. The size of an object is determined by relating it to a set of converging lines on the horizon.

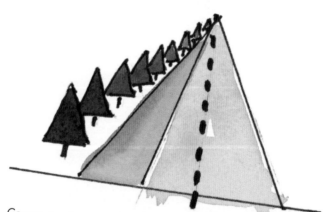

Converging lines create distance to a single vanishing point on the horizon. A series of lines give structure.

Liberate your point of **view**

Stretch your grid.

Alter your perception. Perspective is one of the great illusions of art. There is perspective in everything that shows depth or thickness. In all of Western art we have a constant interaction between narrative intent and pictorial realism. Eastern perspective shows perspective in relationship to size from top to bottom. Near, middle, and far according to distance.

Shape can affect visual weight even though color may be the same. You can create juxtaposition with color and line. Cézanne told Bernard to look at nature in terms of cones, cylinders, and spheres.

Look at the sea. Do you feel that the spatial possibilities are beyond comprehension? Look at the horizon. Think of what is above the horizon line and below it. Everything in art has a relationship. Put yourself in the middle of an imaginary circle out of doors. Look up. See all of the space that is above you. Raise your arms and feel the space. Now go indoors and raise your arms with your palms up over your head and feel space between you and the ceiling. Is there a difference? Turn slowly and look all around you and see how all items are related to each other. Near and far. Up and down. Above and below. Light and dark.

Drawing in the Hoffman manner shows the rushing in and out of horizontal, diagonal, and vertical lines in integrated space.

Check your vanishing point. Alter your perspective and look back to where you are. When creating a work, establish your horizon line or eye-level line first. You can check diagonals by using a piece of string stretched taut from the vanishing point to any direction. Think of the shapes in relationship to each other. Now come back to earth and know that perspective is all a matter of point of view.

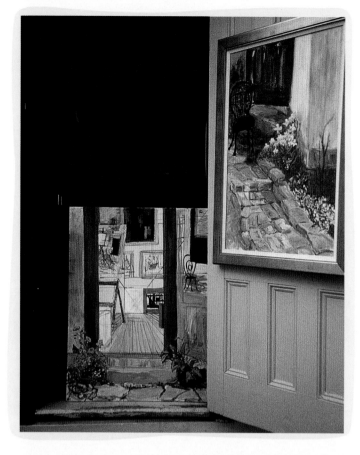

Try using orange against magenta for halation on the door frames. Add luminous gold touches to the foreground. Take chances and try almost impossible combinations; you may discover that you like this mixed-up look. Above, the finished painting propped in the studio doorway.

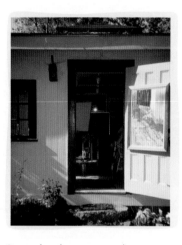

Open the door to your house or studio, paint it as if you were about to walk in.

Try this experiment. Increase your awareness of pure shape relationships by half closing your eyes, and switching attention from meaningful objects to the shapes they leave empty against the background. Negative and positive shapes share relationships. For example, when you look at a tree, you are noticing the positive image of the tree, as well as the negative image of the space around the tree. Consider the tree cut out of the picture, leaving behind its negative or outline only. Seeing is to classify, relating expectations and comparisons. Size has no meaning except in relationships between objects.

One of my favorite perspectives is looking into my studio. It means that I am going to have a new experience: Shadows, diffuse sunlight, dappled patterns create a dramatic effect.

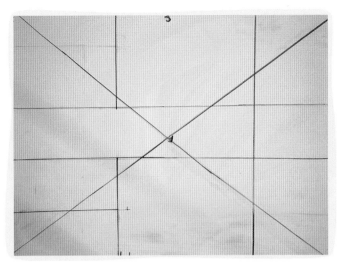

Take a canvas and paint it the color of light.
Draw lines to divide the canvas using the Golden Ratio
formula. (See page 25 for more on the Golden Ratio)

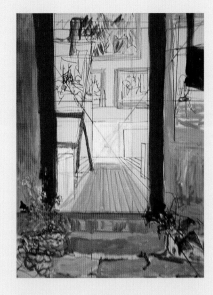

Paint in color and use it as form. Try
Hans Hoffman's "push pull" theory.
Establish foreground, middle ground, and
background, and place vibrations of
colors next to each other, for halation.

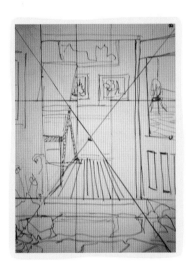

Because you want the viewer to
come into the interior of the studio,
draw lines to a single vanishing
point. This also creates an illusion of
three dimensions.

Foreshortening and seeing around corners: Foreshortening, which refers to the artistic technique of reducing or distorting objects in order to convey the illusion of three dimensions or perspective was first used during the time of Plato. It was considered trickery and sparked critical outrage. Every new concept causes outbursts. Let's raise some noise.

Creating illusions is what we do as artists. Break all the rules. Know them and break them. Consider: until the present time we could not see around corners. You can't walk into a painting and peer around the bend or behind an object. We rely on the artist to provide the whole story. Today we have virtual reality and holograms. The rules are changing.

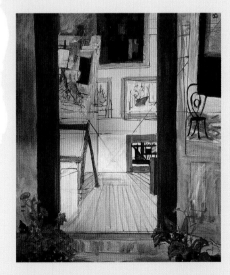

In the finished painting, colors dynamically
interact both in geometry and gesture.
I have dared to include my painted
impressions of four artist/mentors:
Hoffman, Dufy, Mondrian, and Thiebaud.

Papermaking, Inking, Painting, Dripping, Splashing, Squirting, Stamping, Layering, Sweeping, Spreading, Blotting, Pressing, Stenciling C

Papermaking, Inking, Painting, Dripping, Splashing, Squirting, Stamping, Layering, Sweeping, Spreading, Blotting, Pressing, Stenciling C

Papermaking, Inking, Painting, Dripping, Splashing, Squirting, Stamping, Layering, Sweeping, Spreading, Blotting, Pressing, Stenciling Co

Experiment

Expand Your Media Through New Possibilities

The circle belongs to the oldest ideograms. 'O' stands for all possibilities within a given system.

Four workshops in this section challenge you to experiment with your art. You do not have to follow the workshops in order. **Start in the middle.** Begin at the end. Experiment. Plan on amazing outcomes.

The Workshops:

Caves exhibit early art

Sylvia Edwards defies gravity and takes us to a new level of imaging with watercolor. Make whimsical compositions and try embossing on handmade cast paper for a **fresh** dimension. **Invent your own symbols.** Let your fantasy flow. Ride a magic carpet and look down at a new perspective.

Mary Todd Beam issues us a special invitation to her aqua-media master class. Try fluid staining acrylics and **revolutionize** the way you work. Observe the ways staining and lifting on different surfaces create **stimulating**

Relationships are the most important element.

Everyday is your birthday.

results. Experiment, master, and then enhance, block out, sculpt, intensify, learn the mixing virtues of fluid acrylics.

Workshops are dynamite for creating new friendships.

Maxine Masterfield paints without a brush if she wants to. Her **imagination** spurs us. Paint with a broom? Hang paper over a clothesline? **Push paint around with a hose?** No wonder she is the founder of the Experimental Society.

The oldest rock engravings in the world were circles, arcs, and dots made 45,000 years ago.

Louise Cadillac collages, layers, and scratches the surface of our resourcefulness. Layering is connecting. It is filled with **revealed** incidents. Layering can suggest orderly disciplines; geology, archaeology, erosion, sedimentation. It grows from the materials that characterize the twentieth century. **Collaging** parts of paintings **is like keeping a diary** of certain moments of art.

Give yourself a gift.

Where were you when you were lost in thought?

For as long as we have human records, artists have been using symbols, drawings, pictograms, glyphs, paintings, and carvings to convey ideas, events, emotions, and information.

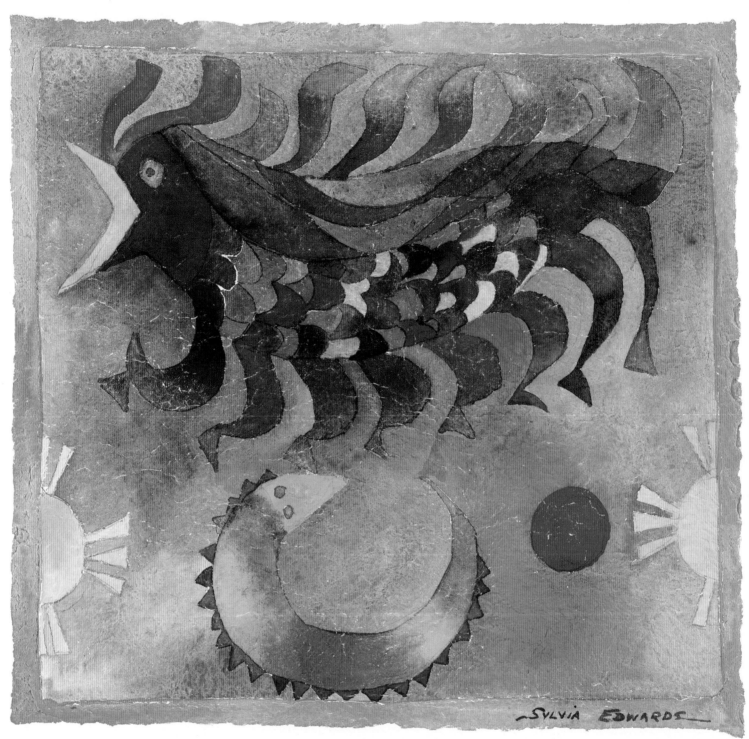

Walking Fish

sylvia edwards

"The nature of paper forced me to simplify my designs.

It lent itself to primitive imagery and suggested a larger, looser type of animalistic form."

—Sylvia Edwards

Sylvia Edwards

Sylvia Edwards

Paintings on handmade paper embossed by brushes, hands, and emotions

Sylvia Edwards changes course constantly. Years spent living in the Middle East, and traveling between studios in London, England and Cape Cod have generated a visual swirl of impressions, styles, and symbols. Her transparent watercolors display aspects of universal human experience. A dramatic juncture in her life combusted her traditional English floral paintings into a departure that liberated representation. By inventing her own set of symbols she created arbitrary divisions of the picture plane into a grid. A formal discipline of color and form took her into imaginative, unexplored territories.

A celebratory view of the world—depicted in vivid, "transparent" paintings—further evolved, creating whimsical, narrative fantasy landscapes freely inhabited by primitive people and animals.

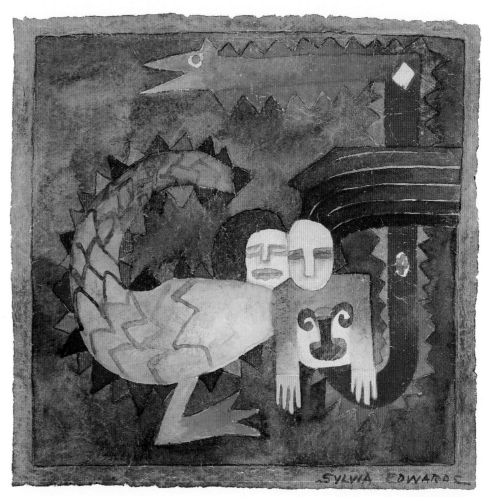

Dragon Couple
watercolor on cast paper
33" x 33"
(83.8 cms x 83.8 cms)

One of the secrets to artistic growth is to stretch your medium. In this workshop, that means changing your painting approach. Follow Sylvia Edwards and make your own cast paper for painting. Using cast paper gives paintings dimension and a sculptural appeal. Edwards also takes a different approach to color-mixing and dividing the picture plane: colors are mixed directly on the paper; pictures are divided into arbitrary grids. She believes that each artist unconsciously creates their own set of grids that resolve into "symbols"—shapes and forms that repeat throughout an artist's work.

Make sketches and try to identify the shapes and forms that repeat in your own work. You'll find—as Sylvia has—that you have your own set of symbols.

Sylvia's invented symbols

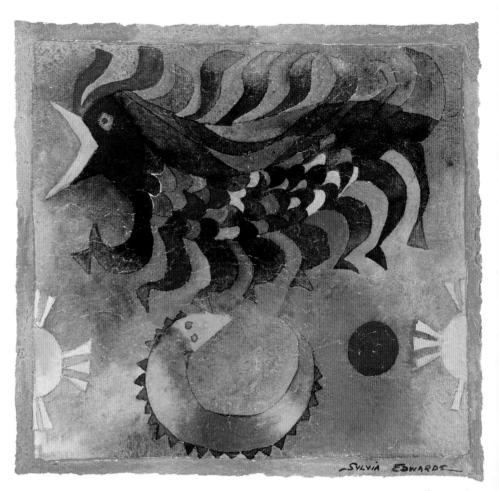

Walking Fish
watercolor on cast paper
33" x 33"
(83.8 cms x 83.8 cms)

Workshop Notes:

First, try a new painting method. Edwards strains mulched paper pulp onto a six-foot by four-foot wooden mold, then swirls in a pigmented pulp mixture to achieve a remarkable action effect. You, too, can make your own sheets of paper (see instructions p.39) and form each to the thickness of your choice. Make oversize sheets and experiment with work on a grand scale. An easy way to begin is to strain large amounts of pulp with window screens and then press out excess water by sandwiching the screens with plywood and running the boards over with a car.

The aim of this workshop is experimentation. The goals are to change the way you mix colors, and to change your usual painting surface by making paper of your own.

Sylvia Edwards

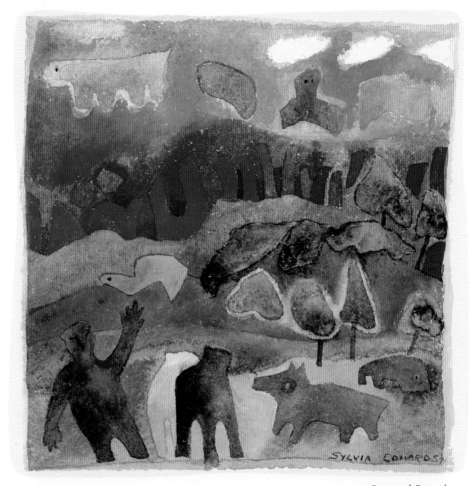

Pastoral Friends
watercolor on cast paper
33" x 33"
(83.8 cms x 83.8 cms)

Early papermaking, from vegetable fibers, developed in China circa 150 B.C.

While the paper pulp is still wet, emboss ornamental designs on the border with kitchen utensils. Edwards makes each piece individually with 100 hundred percent linter cotton pulp. The pulp is distributed evenly, and drained; in drying, oxidation and shrinkage add an uneven texture to the surface.

She paints lively folk art creatures, cubic houses, and floating, dreamlike forms within each cast paper's textured borders. You can try this in your own kitchen. If you like the results, the size can be increased by multiplying the proportions (see sidebar). Small pieces can be dried in a microwave oven, or with an electric iron.

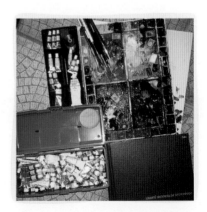

Experiment with your colors. Buying colors in small tubes offers opportunities to play and test a new palette.

Leave colors in the mixing area of the palette: these colors often make great neutral values to complement primary colors.

You may choose to actually paint with paper pulp—or simply use paint on the unfamiliar cast paper surface. Begin a new painting and, no matter what your usual style, aim for a relaxed, almost playful approach. Edwards paints with more than thirty colors. You, too, should try to begin with more color choices than usual. Extend your palette to a wide range of options, then leave all the colors in the mixing area to encourage blended hues. Use a Number 10 sable brush and mix the paint right on the paper. Don't even stop to change the paint water or clean the palette. Try not wiping the brush on cloth; simply brush the colors onto the paper and see what happens.

Sylvia Edwards' interest in primitive cultures and her sensuous celebration of the visual world has taken her to many places, experiments, and exotic new locations. She hopes that you will have the same pleasures by reaching into new visual dimensions.

Brush paint directly on the paper, allowing it to mix and blend on the painting surface.

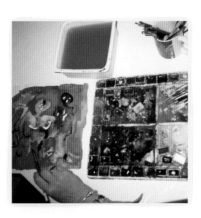

Color dropped directly into wet color adds luminous richness as it melds.

Making Cast Paper on a Small Scale

❧ Tear or shred newspaper, junk mail, old gift wrap, or just about any kind of paper into one-inch (3 cm) squares. For every fifty squares of paper, mix in 4 ounces water. Soak overnight or boil one hour to soften and break down the fibers.

❧ Put into a blender and blend until smooth. Divide in two containers, add 1/2 cup of water to each, and strain. Pour mixtures together again.

❧ Strain onto a piece of screen laid over a container (empty coffee cans work well for draining small amounts.) The pulp will stay on top of the screen. Cover with a second piece of screen and blot to remove excess water. Or remove screens and roll with a rolling pin.

❧ Remove the top screen and let pulp dry as is, or add some pigmented pulp to make a design. Pulp, or the blended paper mixture, can be colored with ink, pigments, food coloring, or dye. Press colored pulp right on top of the wet pulp, or mix it in at step 2. Use an empty plastic squeeze bottle as a pulp gun and make interesting designs.

Song of the Navajo

mary todd beam

"Painting to me is an expression of the spirit of the artist.

To celebrate, interpret, and explore what the human experience involves is my goal."

—Mary Todd Beam

Mary Todd Beam

Mary Todd Beam (signature)

Experiments with fluid staining acrylics

Mary Todd Beam is an internationally recognized artist, a signature member of the National Watercolor Society, and an esteemed teacher. This workshop, Synchronicity, was presented to her aqua-media master class at Bonclarken, a retreat in Hendersonville, North Carolina. The class consists of twenty-eight accomplished artists invited for a week of intense experimentation. Each artist was asked to bring an item for the 'yard sale' table. Participants work at a huge table; with scrapers, rollers, brushes, glue, boards, textured papers, and torn strips of materials, under, over, and all around—a myriad of colorful and enticing parts for yet undiscovered puzzles. This segment demonstrates how staining and lifting fluid acrylics on different surfaces creates stimulating results. Experiment, master, and then be prepared for amazing outcomes.

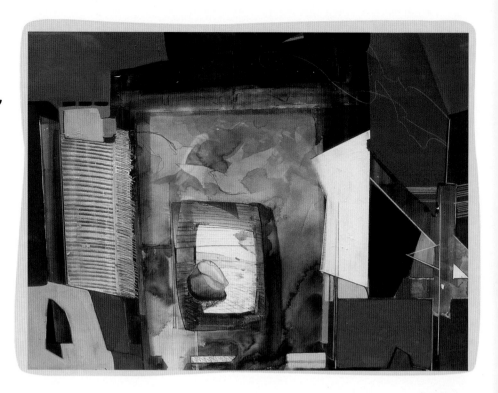

Synthesis
aqua media and collage
30" x 40"
(76 cms x 102 cms)

The medium of choice to begin your own workshop flurry of painting is fluid acrylic paint. Fluid staining acrylics can revolutionize the way you work. These paints can be used as watercolors, made transparent or translucent. Their staining power is great. Try layering them without mixing to create vibrant color. Or use them as a glaze that won't disturb the paint below. Fluid acrylics can be mixed with large amounts of water and will still retain their brilliance. Washes can be produced, as can opaque tints and shades (mix with white or black gesso). A product called "Flow Release" will help thin, delay drying, or to enable you to "draw" in the wet acrylic paint.

In these exercises, you'll consider themes of chaos, simplification, and exaggeration. Strive for a whole new way of seeing. Besides experimenting with fluid acrylics, you'll push patterns around in three simple projects to get your creative juices flowing.

To begin, you'll need a group of house-hold items, such as those shown on the "yard sale" table here. You will also need:

- Crescent board cut into two 18-inch squares and one rectangle
- Fluid acrylic staining colors: quinacridone crimson, quinacridone gold, thalo turquoise
- Alcohol (for cleanup)
- Flow Release
- Gesso: black, white
- Palette
- Putty scraper
- Serrated-edge tool
- Newspaper
- Gel medium
- 3-inch brushes, rollers, or brayers
- Assortment of canvas, paper, crescent board, illustration board, mat board, foam core, textured papers—your choice of surface
- plus additional fluid acrylics or water colors in hues of your choice. When applied over a dried gel medium surface, these will float and puddle, creating wonderful marks.

Prepare one square the day before by applying gel medium with a scraper and letting it dry overnight.

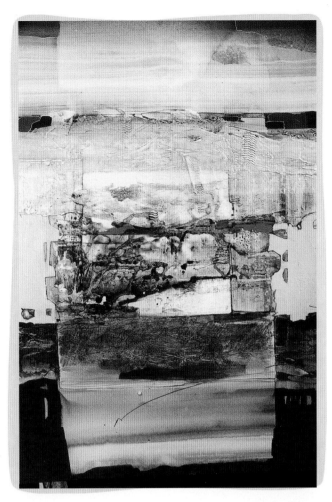

Rock of Ages
aqua media
40" x 30"
(76 cms x 102 cms)

Workshop Notes:

Examine the items on the table through a viewfinder or camera. Look at patterns and geometric shapes as they touch each other. Focus on a small section and draw the items with a black permanent marker. Make a line drawing only, no details. Select something that may be a significant symbol for you. Sketch this on the square piece of crescent board.

Use the scraper to push around a light coating of white gesso. Leave the middle section untouched. Let dry.

Brush over the dry gessoed surface with quinacridone gold and quinacridone crimson. Glaze over colors. You are now minimizing underdrawing.

Paint in lines of black gesso and reconsider the format. Add more design and set it aside.

Save all those treasures from your attic. These are your personal life maps. Paint them.

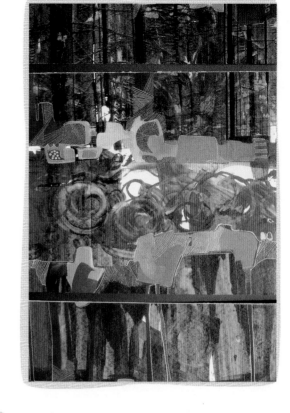

Song of the Navajo
acrylic staining technique

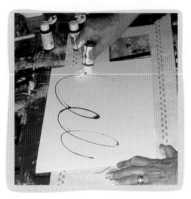

Squirt fluid acrylics on one-half of a rectangular board. Drip on more designs with a brush.

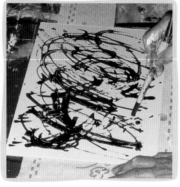

Cover the surface with the three "primary" colors (as listed in the materials list.)

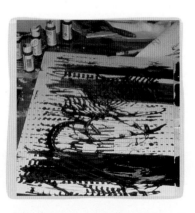

Take the serrated scraper and pull it from top to bottom across the page. Do not go back over any area in the other direction, or the paint will turn to "mud."

Here is a close-up of the designs you can make. When the pattern is dry, glaze over it as many times as you wish, since these staining colors are transparent and translucent.

The resulting layered, or "strata" format helps stretch creativity: the act of layering builds in congenial "accidents" as shapes and colors blend. The large brushes help you eliminate unnecessary details. When painting this way, use a 'V' with the strata format to keep the eye moving. Use circles going out of the picture plane and combine them with an 'S' curve. A grid or a play on the squares gives many design opportunities, including the cruciform.

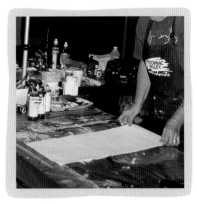

Take a piece of primed or unprimed canvas. A rectangle is nice. Later, it can be hung like a scroll or mounted on a board, fringed, cut or attached to another piece.

Another way to motivate and stretch your art is to examine formats. A vertical format can be strengthened by pushing the subject well above the horizon line. Mountains can rise or an eastern perspective can be better illustrated by pushing the horizon line down. High or low horizontal placement can achieve a more compelling perspective. Try the technique pictured to make a layered abstract painting.

For another approach to layering in a vertical format, with more texture and interest, you can try: using contact paper as a resist; mixing some fine sand with the gesso; mixing salt with gesso; or printing on a gesso surface with a piece of crumpled plastic wrap. When you have finished all three projects, try placing them together on the floor to form one large painting. Use a bed sheet for the background, and leave space in between to make a triptych. If the techniques did their job and caused creative combustion, your paintings will probably all work together as one amazing statement.

Brush or roll on as many good strong colors as you want.

Arrange the colors in a placement that will please you, keeping in mind you will fold over the canvas to print on itself.

Fold over and press, fold over and press again. Continue this process the length of the canvas to give striated horizontal marks.

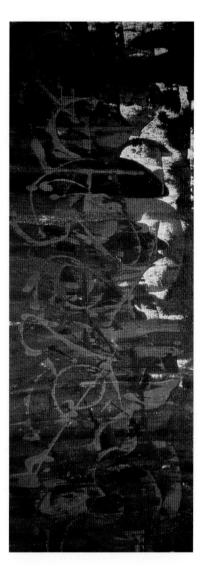

Add black gesso as needed to thin the paint. If you are unhappy with your results, let the whole thing dry and start over. Nothing ever is lost, only restarted.

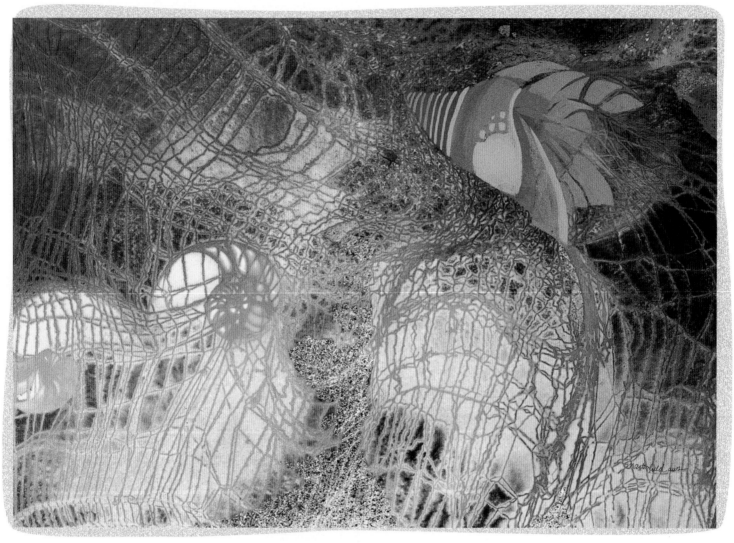

Destiny

maxine masterfield

"Why would anyone want to wake up in the morning and do the same

thing when you can try something new every day."

—Maxine Masterfield

Maxine Masterfield

Maxine Masterfield (signature)

Brush or no brush...

Arriving at Maxine Masterfield's studio, you are likely to I find her preparing for her workshop group by sweeping the sand off a recent painting. Meet Maxine Masterfield, AWS. If it runs, pours, splashes, or squirts, she has probably painted with it. Trained at the Cleveland Institute of Art, Maxine (even as a student) broke the mold. Her quest was to become aware of everything in her environment, to revere it, and to bring her love for patterns of natural materials into her work. Through her years as the founder of the International Society for Experimental Artists, and as a teacher, juror, and energetic source to the profession, she can review her accomplishments and readily admit experimentation is what has fired her success. From beginnings as an artist, she has not adhered to many of the techniques taught to her in art school. Here, she demonstrates the fine art of painting with . . . sand.

Floating
aqua media
22" x 30"
(56 cms x 30 cms)

Maxine Masterfield often paints without a brush. Her experimentation is inspiring. Ever paint with a broom? Hang your paper over a clothesline? Push paint around with a hose? In her studio, the unusual collection of workshop materials could be titled, "Tools essential for a creative explosion." There are brushes of every size, turkey basters, brayers, scrapers, hair combs, droppers, medical instruments (for drawing fine lines), squirt bottles, and plastic pipettes with long noses for drawing, color mixing, or removing excess ink. She also collects found objects to use for embossing, such as leaves, rocks, feathers, shells, papers, plastic sheets, doilies, and slices of geodes or rocks.

Besides advocating experimentation, creative advice is this: Invest in yourself. Quality material, and lots of it, can make the difference in expanding your creativity. People are often too timid with expensive inks and papers. A plentiful supply of materials frees you for successful experimentation.

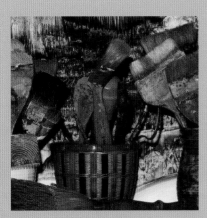

A collection of brushes

A cold palette: The refrigerator in Masterfield's studio is full of inks and paints in plastic squeeze bottles.

The spectrum of ink: fabric, India, acrylic, Dr. Martin's watercolor, permanent, non-permanent, and a little nail polish.

Towles Court
aqua media
22" x 30"
(56 cms x 30 cms)

Workshop Notes:

This workshop demonstrates two ways to create brushless paintings. Sand painting is first on the agenda, and the common broom becomes an important painting tool. You'll work outside, using sand, a broom, and a misting hose to push the sand in patterns and to create mounds in a series of resists. When waterbase ink is pumped onto the watered surface, it will dry in areas where the sand has not streaked or collected. Let your imagination suggest images or control the direction of the colors by turning the wet paper and letting the inks meld, drip or run.

Before you start, you'll need: a bucket of fine, dry sand (beach sand or "pool filter" sand both work well) and an air pump mister (the pressure of the mister will force the ink to go to the surface of the paper not covered by sand). A plastic spray bottle will also work, though it will not have as much power as the mister. You will also need: permanent waterbase ink; D'Arches 140 lb. hot-press paper or foam core; a garden hose.

Maxine Masterfield

Destiny
ink and watercolor
22" x 29"
(56 cms x 74 cms)

Why would I want to paint a nude I don't even know?

To begin, filter fine sand through a large sifter to cover. Sand can be smoothed evenly by hand or guided into a particular pattern. Use a garden hose fitted with a misting head to spray the sandy surface in a gentle back-and-forth motion. This movement mimics the ebb and flow of waves. Of course, if you are near a beach, just put on your bathing suit, hold the paper in the water, and let the ocean move the sand to make patterns.

The preferred ink for this process is Tech Ink or Perma Draft, but other inks will create good effects, too. Choose a product that is light-fast, permanent, and can be used on paper and cotton canvas.

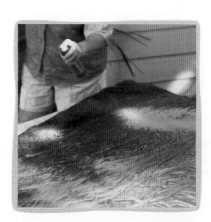

Apply the ink with an air pump mister as shown. (Misters can be reused if you carefully wash them with window cleaner each time.)

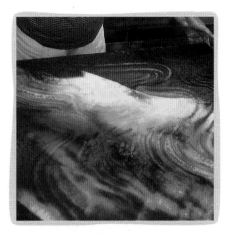

As you apply the paint, always keep a little balance in mind. Tip, turn, and let the paint find its direction.

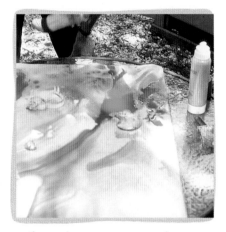

If you choose, you can push cross-sections of the shells or found objects into the wet sand to suggest swirling forms. When you are finished, let the sun completely dry the sand. Removing sand while it is wet will ruin the resist.

When you are planning your palette for this project, keep in mind that every color must be sprayed a little over the page for harmony and balance. Here, the palette of rainbow colors and some earth tones comes from Masterfield's love of nature. She starts the sky with blue indigo. She adds daffodil yellow for sunlight, then adds magenta. Touching the positive and negative edges of the inked areas created by the sand resist will make a visual link. Work from left to right to make an illusion of horizon lines. If a landscape suggests itself, foreground, middle ground, and background should be considered. Work one color against another.

This may all seem very random, but it will emerge as a strategy: much will depend on your experience as an artist. If the paint or ink takes control, follow its lead, you may find a new path. The cutting edge might just be to soften an edge, to let the colors feather together. Other colors are at your discretion. Will you choose green? Will there be a little burnt umber or raw sienna?

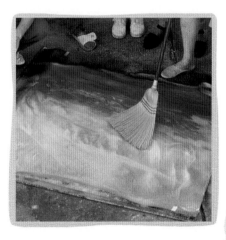

Once dry, sweep off the sand to see what story you have told. Try experimenting further with canvas and liquid acrylics instead of paper and ink.

Sunrise on Neptune
acrylic
24" x 46"
(61 cms x 117 cms)

Clothesline Painting

Clothesline or "arc painting" is another great way to paint without a brush. Work on a cylinder or other rounded surface: clay, sheet metal, cardboard, etc.

- Wet a sheet of D'Arches 140 lb. cold-pressed paper. Drape over the arc or fold over a clothes line.

- Use a plastic squirt bottle of ink with a needle-like point to pull fine lines across the paper. The lines will drip down the paper and the color will flow freely. Clean the needles and cover after each use to keep from clogging.

- When an arc is used, simply leave the paper in place and only work on one side. If you are using a clothesline, both sides of the paper can be worked on.

- An India ink dropper can be used to add additional colors that will run down also. Carefully lay the paper flat on a piece of plywood or art board to dry or to receive more squirts of paint. If you choose, you may add more forms with a brush or let it dry completely and make decisions later.

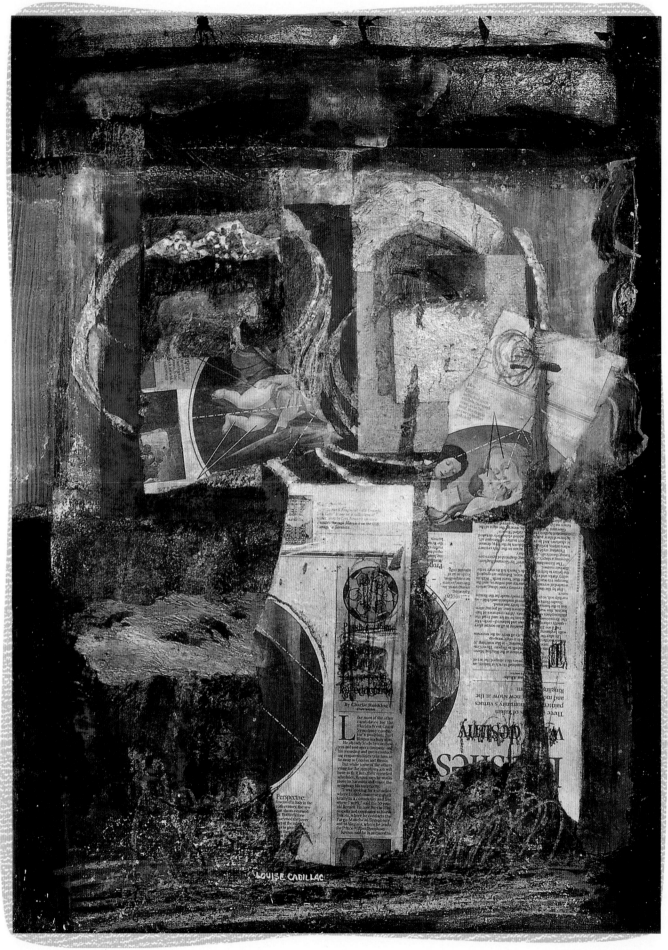

Madonna Fragments

louise cadillac

"Creating a collage from parts of paintings is like keeping a diary

of certain incidences of your vision."

—Louise Cadillac

Louise Cadillac

Louise Cadillac (signature)

Collage and layer—from newspaper to gold leaf

Louise Cadillac collages, layers, and scratches the surface of our resourcefulness. She is an award-winning artist, and recently received the Vincent Van Gogh plaque for outstanding leadership in arts education. A sought-after workshop instructor, Cadillac shares her inventive experimental abstract layering methods. She travels the world teaching workshops and has published many articles in journals and art magazines. Her liberating workshops focus on two important aspects of experimental abstract painting: layering techniques and methods for pulling a work together.

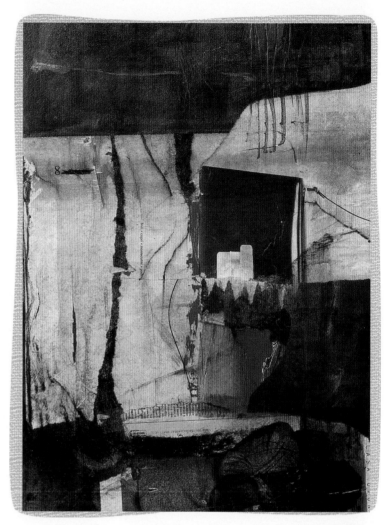

D'Italia
acrylic collage
22" x 15"
(56 cms x 38 cms)

Layering is connecting. It is filled with revealed incidents. Layering can suggest orderly disciplines; geology, archaeology, erosion, sedimentation. It grows from the materials that characterize the twentieth century. This is a workshop on layering to make collages glow. Layering gives a deeper tone and meaning to transparent acrylic paintings. The optical texture of colors achieved by the layering of ten or more coats of transparent overlays of washes, stamping, spreading, scumbling, scraping, and grouping create important secret ingredients for the jewel-like tones reflected.

You will need:

- Hake brush (for gesso)
- A flat, one-inch wide nylon bristle brush
- Three round watercolor nylon bristle brushes, sizes 4, 10, and 16.
- Four-inch wide ink brayer wax-backed place mats cut into pieces
- Plastic paint scrapers
- Stamping shapes (rubber, potato, card board stencils, etc.)
- Implements for making lines, marks, squiggles (visits to the garage, the kitchen, and the hardware store will supply you with inspiration)
- Candles
- Watercolor crayons
- acrylic paint: acra violet, dioxazine purple, thalo blue, thalo green, alizarin crimson, naphthol crimson, yellow ochre, lemon (Hansa) yellow, yellow orange azo, burnt umber (or choose your own favorite palette of colors)
- Shapes and forms from gold leaf, torn newspaper, or pieces from other paintings
- 90 proof rubbing alcohol and water in two small spray bottles

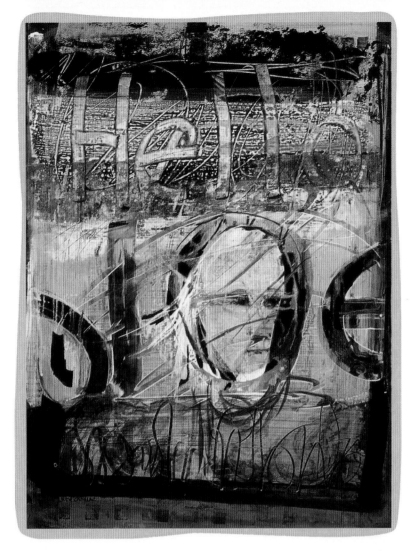

Contra: Cody
acrylic layering
30" x 22"
(76 cms x 56 cms)

Workshop Notes:

The project combines gesso, watercolors, gold leaf, and newspaper. Gold leaf and newspaper may seem like a strange combination, but together they create gems with vitality. Cadillac suggests that you work on multiple paintings at once so you won't be tempted to ruin a damp surface. Always let your work dry completely before going on to the next procedure. Any smooth-surface, good-quality artists' paper will work as a base; favorites for this technique are Fabriano Artistoco 140# CP, Lana #140 CP, D'Arches Hot Press or a 300-lb. smooth paper.

Before you begin, assemble the materials listed and, with a three-inch hake brush, size each piece of paper with gesso and let it dry.

Louise Cadillac

If you like to experiment, reflective materials are fun.

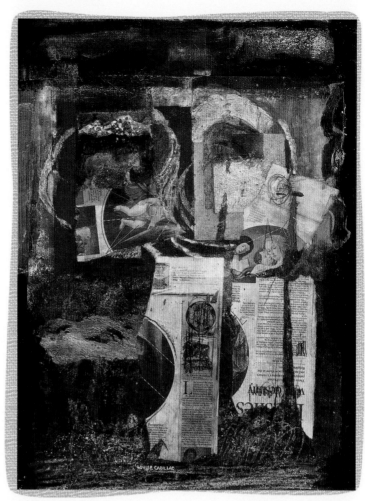

Madonna Fragments
mixed-media on paper
30" x 22"
(86 cms x 152 cms)

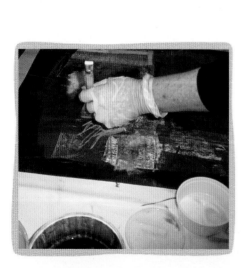

Paint a wash of color over
each piece of paper. When
dry, apply another wash.

Lay the paper on a sheet of white plastic (which can later be cleaned with alcohol and reused). Work to the edge of the paper. A deckle edge for floating completed paintings in frames is especially suited for this type of work. Many brands of acrylic will work, but make sure you choose transparent paints for this project. (Liquitex makes a good line and labels transparent and opaque finishes—making it easy to select the right one.)

As you begin to paint, keep in mind that acrylic brushes should not be left out of water for long because they dry quickly. Wash the brushes carefully after each color application until there is no color left in the ferrule of the brush.

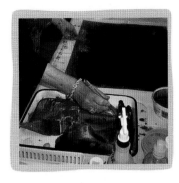

Build up layers of color. After five washes you may want to seal the color. To seal, use gel varnish medium or clear glue for a collage. Paint will glow through this transparent layer.

Once the background elements have come together, collage on paper, newspaper, and faux gold leaf. Newspaper, torn into interesting shapes, can be glued full strength with a gloss medium varnish and carefully smoothed with a brayer. To prevent buckling, papers should be weighted when not being worked for long periods of time.

Place the foil over, under, or alternately with the newspaper. Observe the way the golden metallic sheen really stretches and glorifies the work. A note on working with foil: if you are using paper-backed gold leaf, alcohol will remove the paper backing. Let the project dry completely first.

In *Madonna Fragments,* the painting shown at left, the archway in the upper quadrant is brushed gold leaf on tissue paper. The calligraphy lines in the bottom of the painting are gold metallic crayon. Cover any metallic or foil those areas with a thin finish of acrylic medium to keep gold from tarnishing. These metallic colors can be glazed over with acrylic paint and the surface scraped through for additional experiments.

Spray alcohol on the surface to create a resist and make unusual effects. Since alcohol and water repel each other, strange and unpredictable textures emerge. You can spray over the wet painting, or pour it on and tilt the painting. If the spray stream is fine enough, you can write with it.

After several layers, cover the piece with a solution of diluted gesso. Later you can scrape back to expose covered layers in lines or smudges. Build up the surface with the place mat pieces as desired.

Create new areas of resist with a watercolor crayon, oil crayon, or candle, then seal with a light wash of diluted gesso. Apply carefully to preserve these marks as additional texture. Let dry.

Reflecting on Art

Reflective materials such as gold leaf and metallic foil can stretch your ideas as well as your technique. In *Madonna Fragments,* three different reflective materials are used. Faux gold leaf shines from the top of the painting, brushed liquid gold on tissue collaged in the archway, and metallic gold crayon. To apply metallic foil to a work: Cut a piece the size and shape of the area you wish to cover; brush the underside of the foil with acrylic medium and position the foil shiny side up. Allow foil to dry, then pull off the cellophane with a single swipe. You now have a bright, reflective space. Glaze with clear acrylic gel medium, or paint, as desired.

Save, Glue, Tear, Stamp,

Press, Collage, Compose, Construct,

Assemble, Find,

Sa

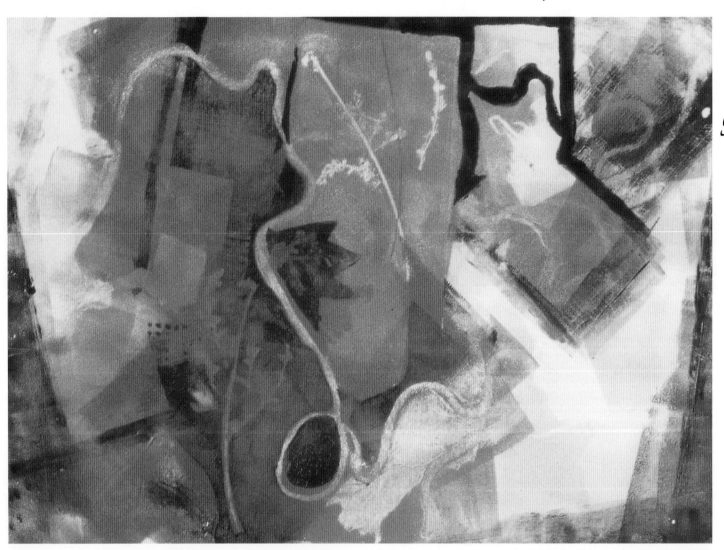

Autumn Debris

Speak, Write, Print

Texture, Restate

Keep, Invent, Say, Alphabet

Glue, Tear, Stamp, Speak, Write, Print

Press, Collage, Compose, Construct, Texture, Restate

Assemble, Find, Keep, Invent, Say, Alphabet

Save, Glue, Tear, Stamp, Speak, Write, Print

Press, Collage, Compose, Construct, Texture, Restate

Assemble, Find, Keep, Invent, Say, Alphabet

Save, Glue, Tear, Stamp, Speak, Write, Print

Press, Collage, Compose, Construct, Texture, Restate

Assemble, Find, Keep, Invent, Say, Alphabet

Extend

Hide a Secret Message in Your Work

Print. Make a series of prints. Repeat the process. Push your envelope.

Would the added dimension of printing, collage, or using words energize your art? Discover a private language all your own in workshops that investigate the power of printing, the printing press, and the printed word as tools to extend creativity.

The Workshops:

Are you a saver of "great stuff?" Joan Osborn

Dunkle shows us how to transform it by combining such techniques as pressing, painting, embossing and reinventing with a hand-turned etching press. **Treasures**, textures, objets d'art, rocks, sticks, pieces of paper, metal, sentimental letters, cards, messages, are these in your inventory of personal meaningful discards? Assemble, construct, and combine them to create new, energized art.

I can do anything I choose.

Create planes

Don't be in the background, stay in the foreground

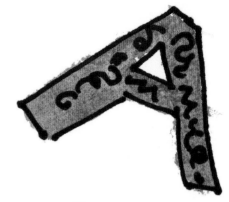

Begin with 'A'

Imagine an organic form of printing that does not require expensive equipment.

Nancy Marculewicz explains how to use gelatin printing to produce monotypes, dye transfers, and stencils. Gelatin printing lends itself to all sorts of multimedia combinations. It invites your **investigation.**

Rose Swisher asks us: Would emotionally charged words impact your art?

The creative act of giving action to intention is yours. Enhance your work with poetry, fond remembrances, expressions of emotion, with Swisher leading the way, whether it's with stamping or handwriting or painting. Our thoughts and emotions give spirit to our message, and we are unlimited in our potential for expressing it. Swisher will teach you to use **poetry** to move your brush. Rubber stamping adds emphasis.

"I try to apply color like words that shape a poem, like notes that shape music."
— Joan Miró

Every word is like a brushstroke.

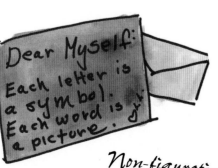

Dear Myself:
Each letter is a symbol.
Each word is a picture.

Non-figurative rock engravings were found etched in Australia. The Panaromitee petroglyphs are 45,000 years old.

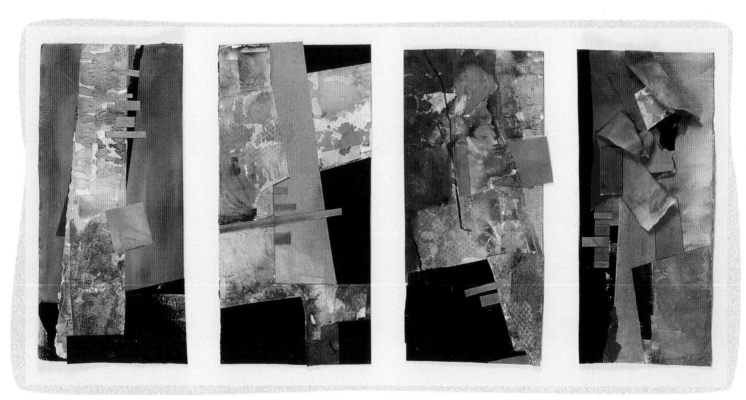

1.S. Series #10
34.5" x 60.5"
(88 cms x 154 cms)

Joan Osborn Dunkle

"A print can be a base to add to or build on, or make a powerful statement of its own.

There is always something more you can do."

— Joan Osborn Dunkle

Joan Osborn Dunkle

Osborn Dunkle (signature)

Transform with an Etching Press

Joan Osborn Dunkle, a natural-born collector, divides her time between her studios in North Hampton, New Hampshire, and Naples, Florida. Moving back and forth between these two very different settings has influenced her work and increased her artistic flexibility. She creates artwork on surfaces ranging from paper to canvas to metal. Dunkle, who has coordinated hundreds of workshops over the past twenty-five years, invites guest artists to give workshops at her studios.

She is firmly of the belief that the more media, styles, and techniques you expose yourself to, the more you extend your creativity. This approach can ignite unsuspecting memorabilia and sentimental items to be considered for collages. She gives us a new look at souvenirs, family photos, and bits of lace or gauze that can add new drama or subtlety to our artwork. Her collection is a treasure bag of ordinary or special remembrances full of items with a past, present, or future.

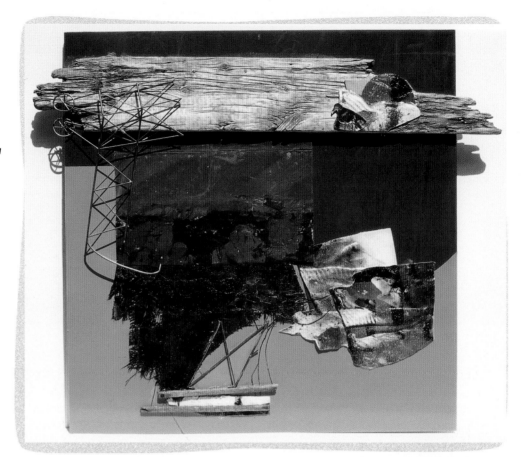

Katie's Karriage
found objects assemblage
43" x 36"
(109 cms x 91 cms)

Assemble, construct, combine. Everywhere we look and everywhere we go, we can be on the prowl for "finds" that can become part of our artwork. An enthusiastic instructor, Dunkle does much more than teach techniques: She expresses a limitless vitality that is infectious. You learn that, as she puts it, "there is always something more you can do."

To make a great assemblage or collage, start by gathering "stuff" you might have saved–all those things that interested you enough to keep. These could be pieces of paintings, scraps of letters, sheet music–and virtually any kind of memorabilia. In her work, Dunkle pays homage to found objects. This is a concept that you, too, can easily work with. Try to develop a "collecting" eye.

Examples of Dunkle's good "stuff":
textured materials, paper, and
pieces of paintings.

Choose the best of your "stuff" to use in
your collages and assemblages.

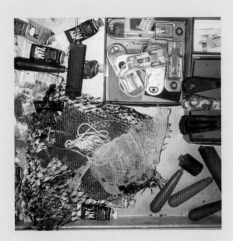

Dunkle assembles her tools in a tray.

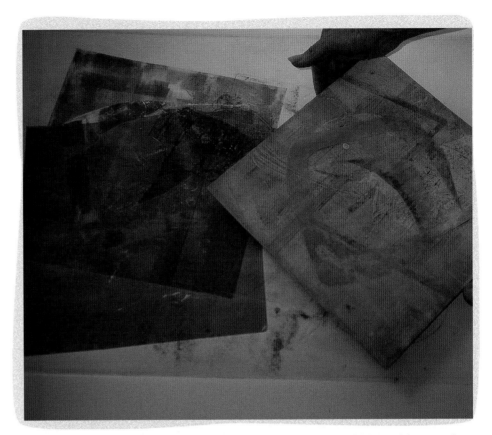

Waterbase oils yield beautiful print colors

Workshop Notes:

For this project, you'll need to gather odds and ends from your collection
of "stuff" as well as the various printing tools listed on page 67 (you can
pick these up at your local art supply store.)

Dunkle employs an etching-press technique to transform her found
objects into art. Hers is a heavy-duty hand-turned etching press. In early
experiments with the press, Dunkle found she was allergic to printer's ink,
so she now substitutes water-based oil paints for ink. This is a perfect
solution if you are sensitive to this material, and you may find that you
prefer it; water-base oil paint washes off easily and yields brilliant color.

If you do not have your own etching press, you can rent time through a
local art group or check with schools in your area.

Osborn
Dunkle

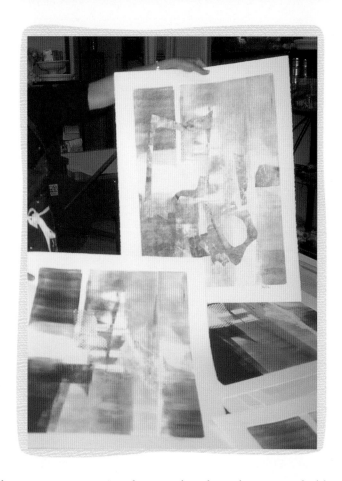

A "ghost image" made after the first print run. Some people prefer the second or third print made from a plate to the first one.

Every room in my mind is full of treasured memories.

Dunkle demonstrates a print that can be altered or extended by printing "ghost" images. When a plexiglas plate is built up with other shapes, such as cut-out materials and textured bits and pieces, it becomes a collograph. Sections are embossed, creating positive and negative patterns. After a first run through the press, try a second or third run, adding additional layers for a chine collé effect. Be careful to place the paper and plate exactly as you did on the first pressing.

Start by selecting a palette of colors. Squeeze the paint onto a glass palette and blend as necessary with a putty scraper or brayer. Next, take the brayer, and roll paint on a Plexiglas plate. Be certain you are working on the rough side of the sheet. The paint should be spread evenly across the surface; consider space, value, and composition or simply let the tools take you where they want to go.

Squeeze colors on glass and blend with a scraper or brayer

As you spread paint evenly over the Plexiglas, you can consider composition and values or simply let the brayer take you where it wants to go.

When you're done painting, and after you have applied any other elements, place the Plexiglas plate on the press in a pre-measured area that allows for margins on all four sides. (You can mark off this area with tape before printing.) Place the paper on top of the painted plate surface. Set the wheel for a smooth, tight turn.

Next, turn the wheel handle in a smooth, continuous motion. Do not stop until you feel you have gone over the piece entirely. (When you have, you'll feel a sort of release.) If you stop in the middle, the paper will have a long dark mark across it.

Use strong pressure to make a design, and add mesh squares for texture.

Now you can lift away the print, pulling it up carefully by a corner of the paper. Try adding another plain piece of paper to make a second print and possibly a third. These additional prints are called ghost images and can often be more beautiful than the one you get from the first run. Use a paintbrush or crayon, if you choose, to add definition when the print is dry.

Carefully place the paper over the plate, taking care to leave space on all four sides. Be certain that the watermark faces down on the plate.

To begin, locate an etching press and collect the following items:

- Brayers or rubber rollers of various sizes

- Brushes

- Putty scrapers

- Paper (try BFK printing paper or 140 lb. watercolor paper)

- Water-based oil paint (such as Max

- Oil Paint by Grumbacher or Aqua Oil by Nor Art

- Plexiglas

- Piece of glass or plastic for mixing paint

Make sure the Plexiglas, which you can have cut at a home-improvement or hardware store, is 1/4" to 1/8" thick and is beveled at the edges. The surface should be slightly sanded or rough.

Osborn
Dunkle

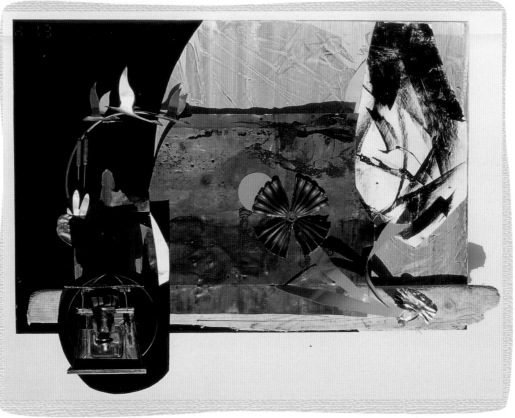

Sassy Sting
mixed media constructed relief
38" x 39"
(97 cms x 99 cms)

A print has a life of its own, or it can be used as the foundation for building an assemblage or collage. You may decide to make a layered collage print using one of your completed prints as a foundation with torn prints, pieces of paintings, or pieces from your "treasure" collection (attach with matte acrylic gel medium or clear archival glue). When the additional layered collage is dry, for a smoother effect, place it carefully on the press and run it through again. (Place the piece in exactly the same position each time.)

Certain shapes tend to reappear in Dunkle's work. Here, she cuts out a spiral.

The Shape of Things to Come

Certain shapes always seem to reappear in Dunkle's work. Examine your own work to see if you have a vocabulary of recurring shapes and forms. Are they predictable? Can you use them to your advantage? Try cutting a shape into the plate itself, and then roll over it with some color on a brayer. The result will be a positive image on the sheet. You can also leave the shape clean and ink the rest of the plate, so that you produce a negative shape on the printed paper.

Compose reliefs or three-dimensional collages with printed papers or torn paintings glued to a piece of illustration board (use non-toxic, archival glue). Try adhering a salvaged piece of twisted metal, to give the composition a curvilinear form. Copper can be bent to create dividing lines between images, or to combine two separate pieces into a diptych.

As Dunkle points out, when you look into your "treasure collection," you will find limitless combinations. You may be inspired to create a fountain from a collection of stones, for example. You never know what will spark your imagination. The next time you are cleaning out the garage, think twice. Is there anything there that qualifies as a "keeper"? If there is, hold onto it. A great pile of "keeper" stuff will serve as inspiration for future projects.

Applying aqua-media paint to the spiral shape

Glue items from your "treasure collection" to a piece of illustration board.

Cut a swatch from a discarded painting and try twisting it to use as a three-dimensional element in the collage.

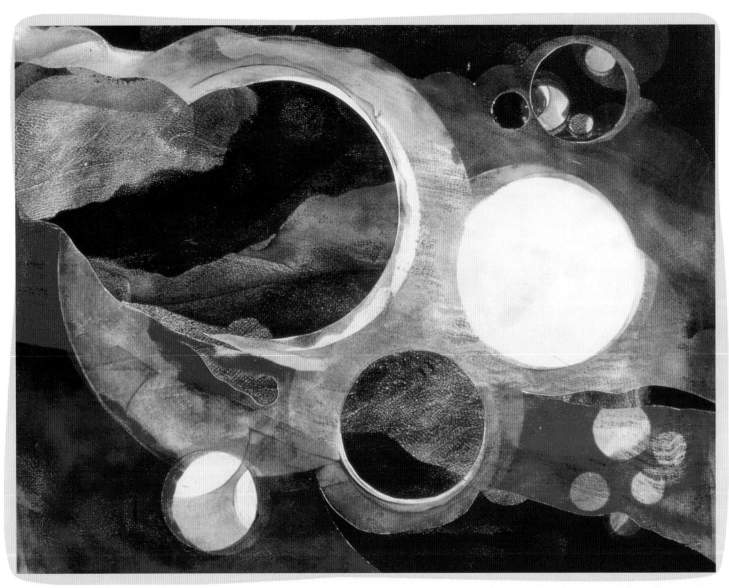

Out in Deep Space

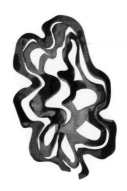

Nancy Marculewicz

"If it looks good enough to eat – it is."

— Nancy Marculewicz

Nancy Marculewicz

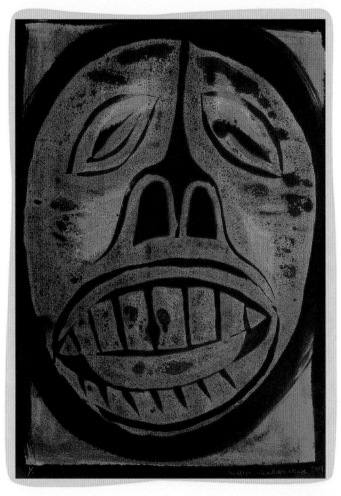

Blue Boy
gelatin dye-lift monoprint
15" x 11"
(38 cms x 28 cms)

Print with Me—
No Press Required

Nancy Marculewicz has taught art at Endicott College in Massachusetts and recently displayed her talent in a retrospective exhibition at Bradford College in Haverhill, Massachusetts. A specialist in painting and printmaking, Marculewicz says nothing has captivated her imagination as much as gelatin-plate printmaking. In her workshop, she focuses on this unique, organic form of printing. Best of all, this method requires no expensive equipment to produce monotypes, dye transfers, series of editions, and stencils. Marculewicz's fascination with masks shows in the demonstration that follows. A single printing plate of a mask allows for dozens of adaptations.

This project is perfect for the artist who has not tried printmaking. The technique lends itself to many multimedia combinations, including painting and drawing. And gelatin-plate printing is easy to manipulate, so there are endless possibilities to investigate.

Deceptively primitive means yield sophisticated results: with a gelatin plate, water-based inks and paints, and no more pressure than that which you can produce with your hand, you'll be able to make images that resemble other methods of printmaking, such as collographs, serigraphs, etchings, and photograms.

Don't be timid; use all sorts
of scraps and shapes.

A plate and a finished print.

To print with the gelatin plate you will need:

- Water-based ink or clothing dye

- A sheet of plastic to mix paint on

- Sharp cutting tools (X-Acto knives

 or leather-cutting tools)

- Tweezers (or dental tools)

- Rubber brayers

- Brushes

- Rubber sponges

- Lots of clean water

- Textured pieces, if desired

- Plastic scrapers

- Paper towels or newspapers

- Popsicle sticks

- Paper (BFK printing paper or an

 inexpensive paper for pulling

 a ghost image)

Floyd
gelatin dye-lift monoprint
15" x 11"
(38 cms x 28 cms)

Workshop Notes:

Gelatin-plate printing is a non-mechanical, painterly way of making monotypes and monoprints that can be done in your own kitchen. Although the process may seem more like cooking than art at the beginning, the finished effects are remarkable. This type of printing is safe for the child within you, or even for a child. Best of all, you'll find yourself encouraged to experiment, because the materials are inexpensive and plates are easy to use and reuse.

First, you'll need to make a gelatin plate. Gelatin plates are simply large, clear pieces of food-grade gelatin—the same kind that is usually colored and made into a dessert. Until you become accustomed to this method, it may be challenging to handle the gelatin. A plate that is too thick will not gel properly; one that is poured too thinly will tend to crack and break. Have patience if the process isn't smooth on the first try.

Out in Deep Space
reconstructed gelatin plate monotype
25" x 31"
(64 cms x 79 cms)

Every day I see a new way.

A variation on the mask print.

Printing with Gelatin Plates:

Follow the instructions on page 75 for making a gelatin plate, and, once the plate is ready (tacky and firm to the touch) remove the clay dam with a sharp knife. Be careful not to tear the gelatin from the glass plate. Finished plates, stored in the refrigerator, will last several days.

Use a leaf or an object to outline, or duplicate a sketch book drawing. To use a sketch, simply place it under the plate and use the sketch lines as a cutting guide, as shown.

The mask print here was made using water-based inks. You can use oil-based paint if desired, but you'll need turpentine to clean up and the plate won't last as long.

A sketch placed under the mold: it is easy to see through the clear gelatin to trace or cut.

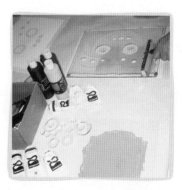

Paint is mixed and applied to the cut out gelatin with a brayer.

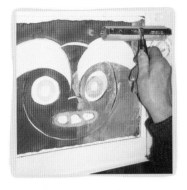

A second coat of paint is added to the plate to print again, for depth and saturation.

Mix the paint on a plastic tray or surface, and apply with a brayer or brush to the gelatin cut-out. Press paper gently onto painted surface, wait a moment for the color to absorb into the paper, then gently peel back the sheet.

To add colors, sponge off the cut-out or blot it carefully with newspaper. Paint more color on the plate and print. If you are using water-base paint, plan to work quickly. For each pass, a different part of the mold may be painted. It will take several passes to make deeply coated impressions.

Try a subtractive approach by mixing fabric dye according to package directions; brush the liquid on several pieces of paper and let dry just long enough so that the surface is not shiny. Press the dyed paper on the gelatin plate. Printing with the gelatin plate on this surface creates surprising results, because the gelatin absorbs the fabric dye as it prints.

Once you get going, you'll find there are myriad ways to use gelatin plates–experiment with resists, overprinting, and layers. Who would have guessed that by adding gelatin to your repertoire you could change the course of your art?

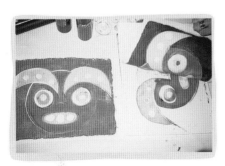

Selected areas are painted different hues to highlight detail.

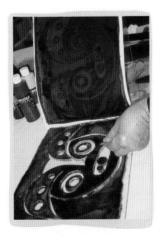

The same cut-out used with a dark palette.

Making a Gelatin Plate

You will need:

- a piece of glass*about the size and thickness of a dinner plate (larger if you prefer)
- Modeling clay
- One or more boxes of powdered, unflavored gelatin

Outline the shape you want the plate to be with a rim or dam of clay rolled in a "finger-thick" rope and pressed firmly in place. Pinch the clay as you go to prevent gelatin from leaking when poured into this outline. Make the rim one-inch high, and let set overnight.

Prepare gelatin by mixing gelatin and half the water indicated (see below); bring the other half of the water to a boil, let cool slightly, and add to the gelatin/water mix. Cook carefully over medium heat until clear.

Determine how much you need based on the square-inch size of the plate:

- 2 tablespoons powdered gelatin + 1 cup water = 1 cup cooked gelatin
- 1 cup cooked gelatin covers 6" x 8" (1/4" ht)
- 3 cups of cooked gelatin covers approximately 12" x 12" (1/4" ht)

Stir cooking gelatin to eliminate bubbles. When gelatin is clear, remove from heat, let cool slightly, and skim any surfacing bubbles.

Be certain the plate is level, pour gelatin slowly into the clay rim, and let spread evenly so that it is at least 1/4" thick. Sweep any bubbles to the rim with a paper strip. Let set several hours, until firm.

*Use existing glass or have glass cut to size and ground or taped to smooth the edges.

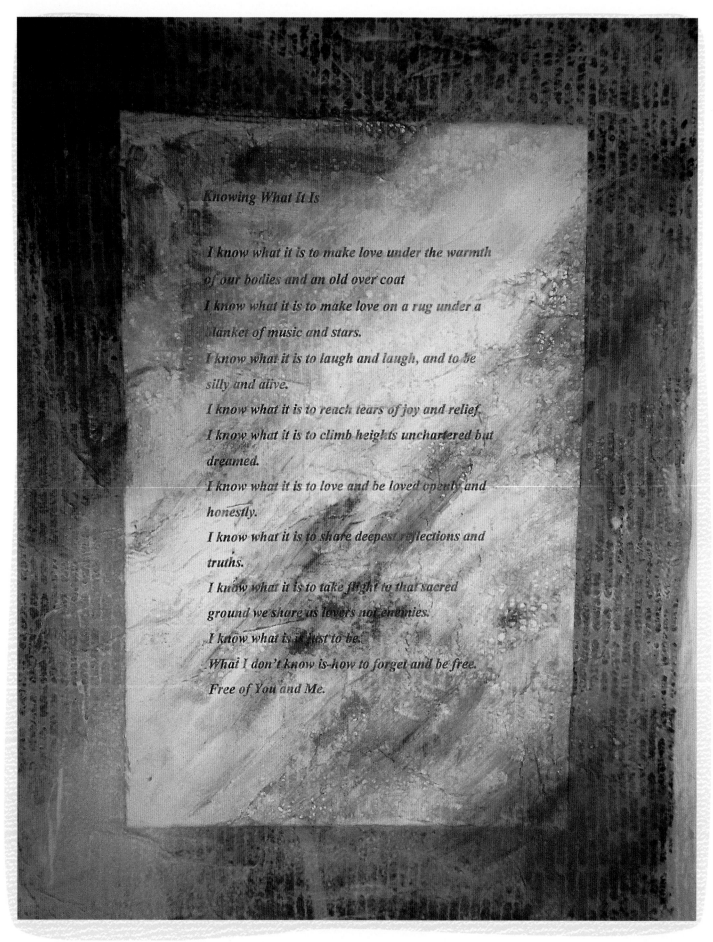

Knowing What It Is

I know what it is to make love under the warmth
of our bodies and an old over coat
I know what it is to make love on a rug under a
blanket of music and stars.
I know what it is to laugh and laugh, and to be
silly and alive.
I know what it is to reach tears of joy and relief.
I know what it is to climb heights unchartered but
dreamed.
I know what it is to love and be loved openly and
honestly.
I know what it is to share deepest reflections and
truths.
I know what it is to take flight to that sacred
ground we share as lovers not enemies.
I know what is it just to be.
What I don't know is-how to forget and be free.
Free of You and Me.

Rose Swisher

"If you create from the heart, nearly everything works; if from the head, almost nothing."

— Marc Chagall (1887-1985)

Rose Swisher

Rose

K. Swisher

The Artistry of Painting with Words

Rose Swisher's artistry is in creating images of her thoughts—each word is like a brushstroke; word paintings of emotions that flow onto her paper. Color and embellishment come later, as an extension of her feelings. Savored private moments, snatches of remembrances, expressions of strong emotions, are carefully penned at the kitchen table. Her Northern California "sanctuary" is on a knoll of Redwood trees that tower above a creek whose bed snakes along a rugged path to the Pacific Ocean. She believes that we are unlimited in our potential for expressing our message, whatever that message may be.

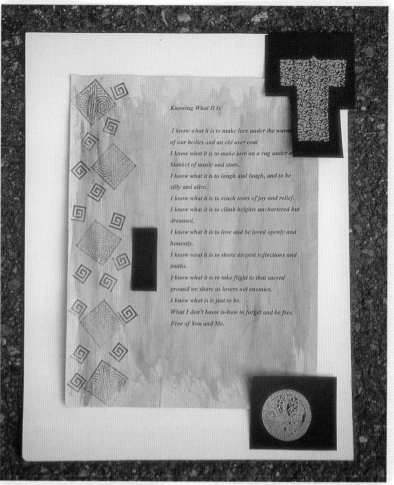

Balance the finished image with cut-out shapes and stamping.

In her workshop, Swisher teaches that words can be used as a medium. She uses poems and bits of text that express her emotions or tell about an important event in her life. You can do the same. Extend your art by writing on paper, your computer, or any other surface that you choose. Then combine your words with other media. For example, you can paint colors that evoke the mood of your writings and then print the words over this surface.

Think of what impact your words could have on your art. Place no limits on your expression—you can create any message you like. Then consider how to emphasize your message and boost its power with color, stamping, collage, and embossing.

Knowing
What It Is

I know what it is to make love under
the warmth of our bodies and an old
overcoat

I know what it is to make love on a
rug under a blanket of music and stars.

I know what it is to laugh and laugh,
and to be silly and alive.

I know what it is to reach tears of joy
and relief.

I know what it is to climb heights
unchartered but dreamed.

I know what it is to love and be loved
openly and honestly.

I know what it is to share deepest
reflections and truths.

I know what it is to take flight to that
sacred ground we share as lovers not
enemies.

I know what it is just to be.
What I don't know is—how to forget
and be free.

Free of You and Me.

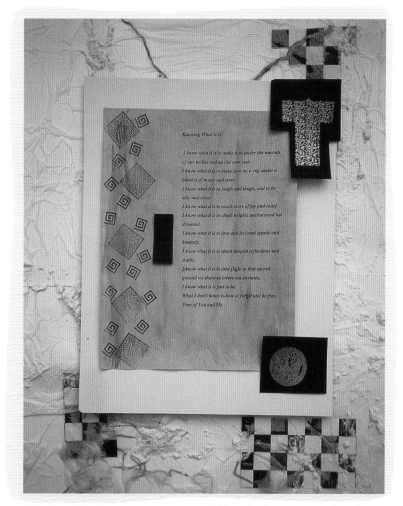

Add and subtract textured surfaces.

Workshop Notes:

There are no set rules to how you go about creating your artwork when
you paint with words as Swisher does. Sometimes she paints the paper first
and then adds text, and other times the paint comes after she has printed
the words.

Even the size of the text is variable. Try using an enlarged copy (which you
can have made at a local copy center) of the text you have chosen to paint.
Print the enlargement on watercolor paper; some copy centers can make
copies as large as the size of a poster.

Once you've got the text and work surface established, take the message as
far as it will go, adding all kinds of artistic elements to embellish it. Swisher
believes you should add as much to a piece as you feel will enhance it. It
all depends on what you're trying to say. At left is an example of one of
Swisher's poems that became the foundation of these paintings.

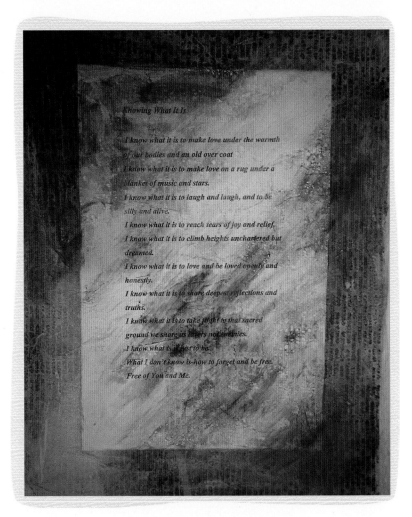

The finished work, embellished with paints, gold, texture, and stamping.

The language of art knows no boundaries.

Begin with a good-quality enlargement on watercolor or handmade paper. Choose paper that is somewhat absorbent, so it works well with glues and water-based paint. For the piece shown here, Swisher uses a mixture of acrylic paint, thinned with water, and acrylic medium. Her shimmering palette is made up of iridescent copper, quinacridone magenta, and Hansa yellow.

Glue the enlargement to an existing or unfinished painting with similar textures. Alternatively, you may choose to work with words and background at the same time. If so, simply glue the text to a larger sheet of watercolor paper. Add a layer of vellum, lacy fabric, handmade paper, or other translucent material. This will create depth, dimension, and texture. Swisher uses archival glue to attach the layers, then brushes on washes of acrylic paint—led by instinct and the emotional message she wants to convey.

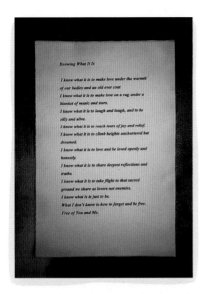

The enlarged copy is glued to a surface with similar textures.

Another inventive way to capture your mood is to create what Swisher calls "mat doodles," which are pieces of old mat board that you have decorated to give them new life (see sidebar). If you like, you can even glaze over the mat and the printed piece with various colors as an extra element. Spray both with a clear acrylic paint to seal.

For extra polish, try a heavy gloss clear-coat paint, such as Glass Kote. Brush it on with a soft brush or a foam brush, or drip it on with a tongue depressor: It goes on like nail polish. One coat is usually enough, but you can apply a second coat is necessary. Three-dimensional work may require additional coats. Working with words, as Swisher does, is a good approach for capturing the rhythms of your life; experiences, words, and punctuation intermingling with colors, textures, and forms.

A sheet of lacy, handmade Oriental paper is layered over the surface.

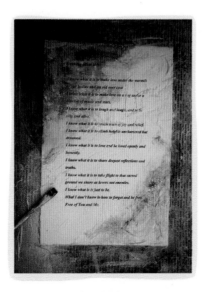

A wash of three acrylic paint colors builds the mood.

Making "mat doodles"

Swisher suggests that you try her method of making "mat doodles." Every artist has mats that have been cut but are no longer in use. Here's a chance to put them to work for you.

First of all, keep cut mats handy: They should be in a convenient spot for marking, painting, stamping, glazing, or covering with fabric. You might keep them by the phone, for example, so that they're nearby for you to sketch on or paint while you talk. This is also a great way to express subconscious thoughts and feelings.

Decorated mats become works of art in themselves, or you can use them as frames for poetry, a photograph, or a painting. Try taking a favorite saying and surrounding it with a "mat doodle" of your own making.

Culture, I

DNA, Drama, I

Computers, Emulsion, S

Exotic Inspirations

Paint Your Genes, Your Heritage, Beyond

Our cells have clocks

Each of us comes from a unique place in our art.

Who we are is influenced by our genes; the culture we live in provides experiences. Memories, dreams, and travel take us further. The **magic** of mental and physical creative journeys is an inspiring force for creativity.

The Workshops:

Rafa Fernandez tells of painting intrigue: of creating magic, mystical figures that leave viewers wanting to know more. The culture of Fernandez's native Costa Rican culture influences his illuminated colors. He tones his images of women with veils of gauze-like auras. **Where does his imagination take him? Where does your imagination take you?**

You never know who your teacher is going to be.

Technology and science are my allies.

Becoming Legendary Takes A Lot of Doing and a lot of Painting

The computer is just another way of seeing.

Juan de la Cruz Machicado pays homage to his home country of Peru. His workshop will help you raise your horizons—and layer your love of your culture in emotional, narrative landscapes. A patriot and dedicated citizen, his politics dictate his paintings. **Look at your natural surroundings.**

Connect me to a computer and I can go anywhere.

DNA is not a myth

What makes your artist's heart stir? Soft edges, buildings, angles, textures speak to us of truly being unique in our translation.

I take my art with me wherever I go.

Julie Newdoll takes her fascination with science and marries it with art. Follow her as she **transfers an idea** from a computer-generated image to a piece of paper to canvas to performance art; taking a single concept as far as can be imagined. Newdoll demonstrates photo transfers, stamping, scanning images with paint or emulsion, and, finally, presents her art as a performance in the Czech Republic.

Dancing DNA are attached at the hands and feet. They give me life and wisdom.

DNA has a strand-like tail; it gets shorter, causing life to end. Find a way to end this and you could live forever.

What is the value of your experience?

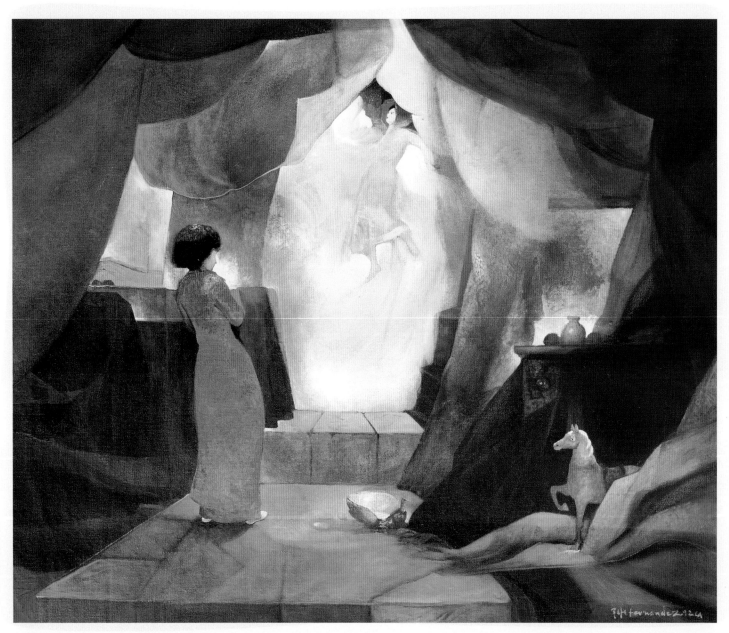

Remedios La Bella

Rafa Fernandez

"The attitude I assume is that of the interior of a magic world where everything is natural and normal, from a levitation to the metamorphosis of a person."

— Rafa Fernandez

Rafa Fernandez

Rafa Fernandez

Toning and Glazing Create Intrigue

Rafa Fernandez was born in 1935 in Costa Rica, a country whose culture deeply influences his work. Fernandez's themes are of the spectacular—witches, magicians, healers, apparitions, myths, rituals, and legends are portrayed. In his paintings, a mystical quality pervades: glazing builds a hazy veil, an aura that transcends to another realm. Much of the work is portraits of figures waiting for events of great consequence to materialize; something Fernandez attributes to his own existential experience. He describes the figures as. "intemporal and also temporal.
I don't profile actual persons, however, I believe in these figures. They represent a vital element in nature. Many times what is perceived as spectacular in my work is its difference. This is the center of my own intention."

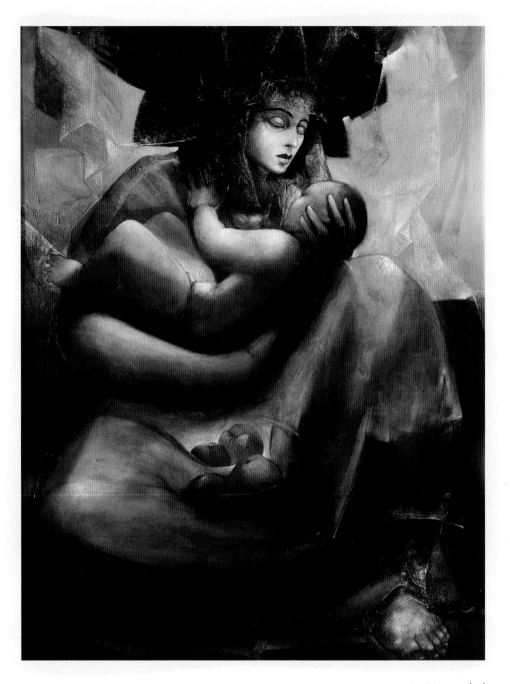

La Maternidad
oil on canvas
63" x 45"
(160 cms x 114 cms)

This demonstration illustrates Rafa Fernandez's technique for "surreal luminosity" that infuses painted objects and persons with new vitality. Notice, as you study this approach, how he often echoes one figure with another, or suggests a spiritual embodiment. In all of his works, Fernandez finds that the colors will "dictate" to him and become richer and deeper in the process. The key to creating this effect is glazing and toning.

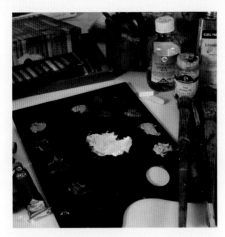

As you can see from his palette, Fernandez uses many brands of paint—whichever offers him the color he's looking for. Here he has laid out ultra-clear blue, zinc white, oxide rouge transparent, cadmium yellow, and orange.

Remedios La Bella
oil on canvas
39.5" x 32"
(100 cms x 81 cms)

A color sketch is a point of departure.

The linen canvas is toned with ocher and cadmium red acrylic paint

Workshop Notes:

Fernandez starts by making a color sketch that acts as a point of departure for his idea of the painting. He makes the drawing in dry pastels over rough paper, developing it until he is satisfied that the shapes and form imply the substance of his idea. Next, he tones a linen canvas with a mixture of clear ocher and cadmium red acrylic paint. He adds a touch of blue, not only for variation but to suggest textured shadow. When this is completely dry, he sands the surface with fine sandpaper to give it tooth. Then he draws the outlines of his subject matter with white pastel chalk, using his color sketch as a reference.

Rafa
Fernandez

Defining some of the facial features and details of the robes and figures, and toning other parts of the painting with clear oxide to enhance luminosity.

"I will paint my heritage. It is in my genes and spirit."

The work shown here is called *Encounter.* For Fernandez, "beginning a painting is like starting a new life; it is always an adventure."

With a very large, soft brush, Fernandez paints the major areas of the work: the background, faces, robes, and figures. As he works, he incorporates colors such as cadmium yellow, vermilion red, and clear cobalt violet to enhance the work's sense of mystery. Then he turns to the details, defining facial features, the robes, and the figures.

The next step is building the luminosity of the painting. Fernandez uses clear oxide to tone parts of the work. He lets

A large, soft brush is used for major areas, such as the background, faces, robes, and figures.

the painting dry over several days, then rubs the surface of the painting with a cloth soaked in linseed oil. When this is dry, he removes the excess oil with a dry cloth, leaving only a thin layer. This step makes the color spread over the painting more easily.

A detail of Fernandez's painting, *Encounter*

Next, Fernandez mixes Van Dyke oxide and Prussian blue on his palette. This mixture creates a dark glaze that he uses to cover the entire surface again. He lets the painting sit for fifteen minutes, then uses a clean cloth to remove any residue. Now he lets the painting sit for several days until it is moderately dry (it should be a little tacky to the touch).

The surface of the dry painting is rubbed with a cloth soaked in linseed oil. The excess linseed oil is then removed, leaving only a thin layer.

Luminous Glazing

* For this method to be successful, you must follow all of the steps to achieve luminosity. It is important that the work remain plastic until the end.

* Make a dilution formula for your paint (Fernandez suggests mixing brands of art supplies as needed to accomplish your painting goals): add to a small quantity of linseed oil mixed with three drops Cobalt drier and turpentine.

* Glaze lightly over the entire work and let dry. Layer glazes for additional brilliance.

Notice the intrigue the dark glaze adds to the faces.

Rafa Fernandez

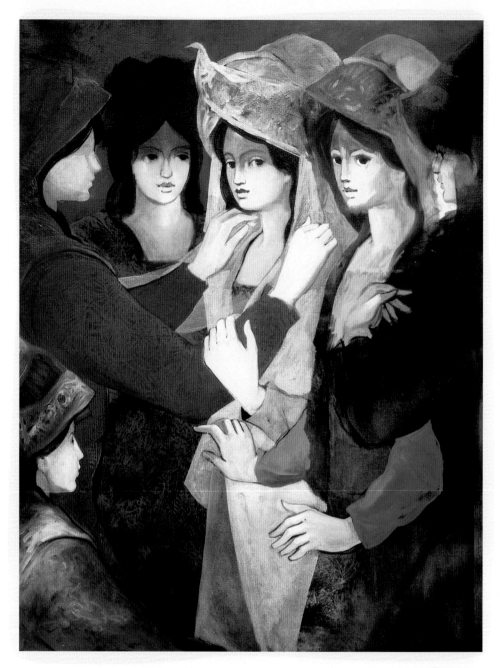

Encounter
oil on canvas
63" x 45"
(160 cms x 114 cms)

Fernandez has by now established three zones of color intensity: dark, middle, and light. He retouches the painting in each of these zones. He uses a mixture of thalo blue and black marte for the dark zone. For the intermediate, or mid-tone, zones, he employs a mixture of alizarin crimson and oxide transparent. For the clear, or light, zones, he brushes on a well-thinned transparent oxide. He lets the painting dry for several days before working on the last stage.

Fernandez next examines the painting for colors that may not be as strong as they should be and works to bring them out. To emphasize the blue dress on the person on the left, for example, he covers it with vermilion red and ultramarine blue. He renders the protagonist in attention-getting gold so that her significance will be apparent and uses zinc white with a tint of clear magenta to give the faces luminosity.

Additional glazes consist of a mixture of celeste blue, clear violet cobalt and clear magenta.

To emphasize the blue dress on the left, Fernandez covers it with vermilion red and ultramarine blue.

When the painting is dry, Fernandez glazes it with a blend of transparent oxide and Thalo blue, which he applies with the gentle strokes of a very soft #10 paintbrush. He applies additional glazes consisting of a mixture of celeste blue, clear violet cobalt and clear magenta, and adds the final details with soft brushes ranging in size from one to ten.

An upclose look at the women's mysterious expressions.

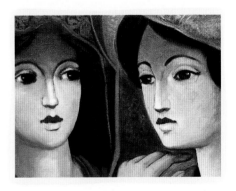

Final details are added with soft brushes ranging in size from one to ten.

Almudena Donde Guardas Mis Tesoros

Juan de la Cruz Machicado

"My culture is filled with seductive color. I sketch with oil paint boldly:

My brush strokes mimic the shapes of the mountains. The countryside invites me to use a

variety of greens. The horizon shows me shades of violet."

— Juan de la Cruz Machicado

Juan de la Cruz Machicado

Machicado

Painting Testimonies to Culture and Heritage in Oil

Juan de la Cruz Machicado, Peruvian artist, made his mark as a child when he used his father's donkey as a canvas and learned to love color by the movement of the animal. He also made paintings on rocks, which he placed along riverbeds to be discovered. At age 18, he was discovered when he received a scholarship to the Fine Arts School of Cusco. He also studied on scholarship in Lima, Peru, and in Paris, France. He has taught at the Diego Quispe Tito School of Fine Arts in Cusco and is a trained conservator. Many of the paintings he restores are from Peru's colonial churches. Machicado's paintings, which reflect his sincere love and affection for his native town of Puno in southern Peru, are exhibited, collected, and shown on all four continents. His focus is to help painters express passion in their work.

Interior En San Cristobal (San Cristobal Interior)
oil on canvas
20" x 24"
(63 cms x 67 cms)

Juan de la Cruz Machicado does not want to claim an "ism" in his work: What he suggests to you is that you are responsible for the place where you live. He feels it is an obligation, a duty, to express what you live and breathe every day. His homeland, so rich in folklore, poetry, philosophy, politics, and religion is very different than other places in the world. Machicado lives by not following the mainstream in art, but by totally expressing his own passion.

Paint a reflection of your life. Keep a dialog with the canvas and be completely open so that you can create something unexpected. Think deeply about where you come from. Work in the present with a vision to the future. "I have the very strong influence of my Incan ancestors," says the artist.

Barrio Querido-Cusco
(My Dear Neighborhood)
oil on canvas
28" x 35"
(71 cms x 89 cms)

Almudena Donde Guardas Mis Tesoros
(Almudena Where I Keep My Treasures)
oil on canvas
39" x 48"
(99 cms x 122 cms)

El Corazon Del Cusco
(The Heart of Cusco)
28" x 35"
(71cms x 89 cms)

Cerca al Cielo (Close to Heaven)
oil on canvas
60" x 48"
(152 cms x 122 cms)

Workshop Notes:

Constantly observe nature. Practice drawing and sketching. Observe works by other artists and visit museums everywhere you go to see how other artists have been inspired by their local culture. Think deeply about where you come from. Maintaining the traditions of your culture is a responsibility.

Feel free to use non-traditional elements. Try drawing with tools, clay, or wool dyed in different colors. Construct with pieces of plastic, and items both ancient and modern. For a special project, Machicado employed "tortora," reeds taken from near Lake Titicaca, to build a traditional Incan boat for an international art festival. The boat is now in the Volkerkundemuseum in Heidelberg, Germany. Look to changes of season, sunrises, sunsets, myths, and legends to stir your artistic response.

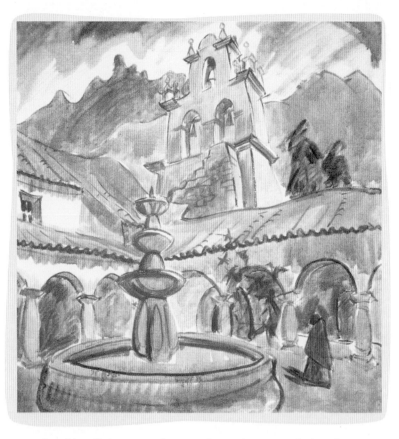

The old walls have a red stain, often with pieces of white from the old stucco.

I paint who I am and what I believe in.

The landscape inspires Machicado: "I go outside into the brilliant, almost theatrical South American sunlight and a scene speaks to me. Often I paint the beautiful forms I see in churches. Like museums, they hold so much history. They are the places of spiritual refuge for this area." Are there locales or vistas near you that spur you to create? Follow your impulse.

Adopt Machicado's technique and begin your sketch with chalk, then sketch boldly with oil paint on canvas, using thin, diluted colors. Gather your palette from the landscape. Here, the old walls have a red stain, often with pieces of white from the old stucco. Transparent, clean blue makes the sky. The artist's brush strokes mimic the shapes of the mountains. The countryside invites him to use a variety of seductive colors: green, orange,

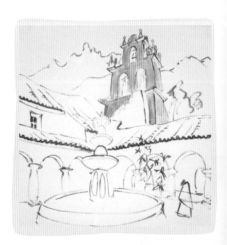

Sketch with oil paint boldly on canvas using thin diluted colors.

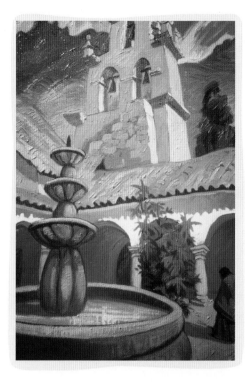

violet. For every warm color there is a corresponding cool color. Complementary colors weave in and out of shadows and backgrounds. Colors, shadows, and large forms are intensely built up with thin washes of color.

La Iglesia del Pintor Sapaca
(The Church of the Painter Sapaca)
oil on canvas
51" x 39"
(130 cms x 99 cms)

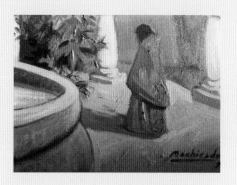

What color is your landscape?

Try building up the color in your work. Machicado makes the tile roofs of the houses in the painting cadmium red-orange. The clothing of the native people has enormous contrasts: blues, reds, yellows, oranges, pale ocher and black, and Machicado is not afraid to use them all. For every warm color use a corresponding cool color. Weave complementary colors in and out of shadows and backgrounds.

Notice how edges disappear and reappear. There seems to be no lines, only provocative angles and forms softly meeting each other. Raising the horizon—as Machicado does in this work—leaves a smaller sky and emphasizes the subject.

In the finished painting, layers of color produce balance, sunlight and shadows give depth and create dramatic patterns of foreground, middle ground. The stately, rising church in the background frames the church bells, symbols of welcome, while dark shadows touch sharply lit walls. A worshipping figure completes the narrative. (See sidebar.)

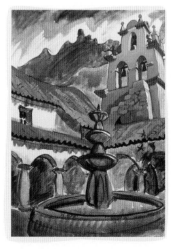

For every warm color use a corresponding cool color.

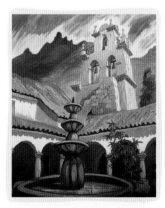

Raise the horizon to leave a smaller sky. Machicado craves provocative angles and forms.

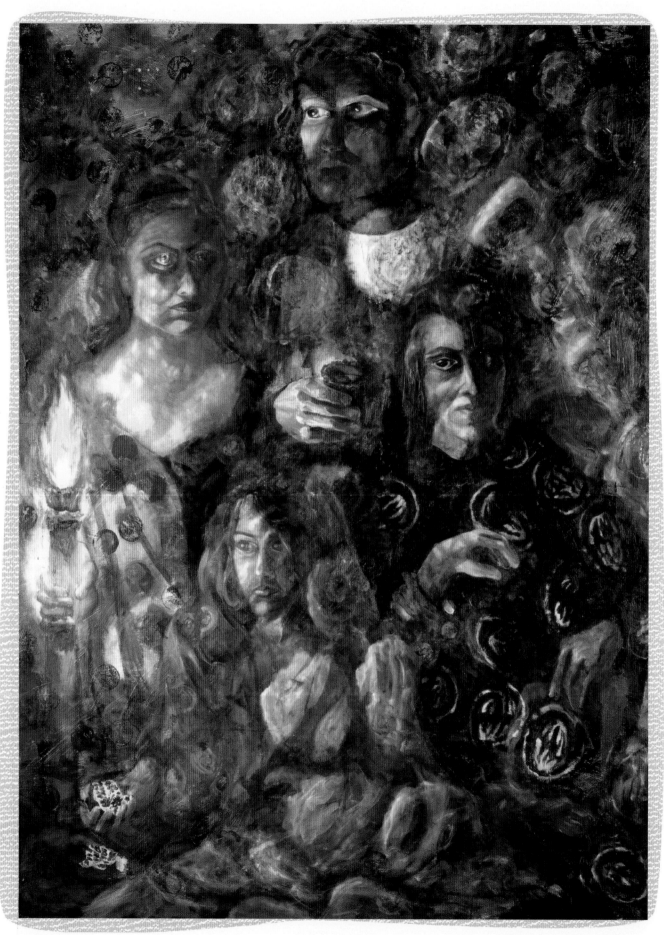

Greek Tragedy Through Necrobiology
48"x 36" (122 cms x 91 cms)

Julie Newdoll

"The patterns of DNA looks like people holding hands and feet with other people, like a ladder."

—Julie Newdoll

Julie Newdoll

Julie Newdoll [signature]

Take a Subject that Intrigues You as Far as You Can Go: From the Canvas to Performance

Julie Newdoll takes her special interest in science and blends it with art. She uses methods that include transfer by photograph, stamping, scanned images, and cyanotype printing. Going steps further than she had ever imagined took this Texas–born artist to the Czech Republic to present her art and to perform. Newdoll earned a B.S. degree in microbiology from the University of California at Santa Barbara and an M.S. in medical and biological illustration at the University of California at San Francisco. Newdoll is the supervisor of digital lighting for three-dimensional computer animation and special effects for movies made at Tippett Studio in Berkeley, California. Recently, she completed an artist-in-residence program at Project Hermit, Plasy, Czech Republic.

Evolution of Sight, oil on canvas, as originated by a computer-enhanced image

Interplay between the artist and computer, a fascination for her subject, and the magnetic current of the canvas motivate Newdoll. Relating scientific concepts (taken from computer-enhanced images) to paintings has become a vital element in her artistic life. She encourages painters to pursue their interests and experiment with the technology available. Her knowledge of DNA, cell division, the shape of proteins, the effects of estrogen on herself as a woman—these are the themes that are translated to her canvas, through research, the computer, and by meshing photographic images with oil painting.

You do not have to be a computer expert to transform your ideas into art. Digital cameras, laser copies, photographic emulsions (which can be made with or without a darkroom), computer graphics, scanners, photo and laser transfers, even acrylic matte gels are all ways to manipulate, duplicate, imitate, or fabricate. Experimenting with and combining these media can increase your artistic vocabulary.

Julie's interest is in science as it relates to art and man. Cells tell life cycles. She relates proteins to events in her life. Each atom shows the shape of the protein. These stamps were created to link cell division to themes of Greek tragedy.

Demeter is the whole cell.

Dionysus shows the cell beginning to prepare for division. He dies a brutal death, torn from limb to limb but is reborn every spring.

Hades wears the cell as it rips apart.

Persephone wears the cell as it has just divided, two different cells just separating, symbolizing her existence in two worlds—earth and the underworld.

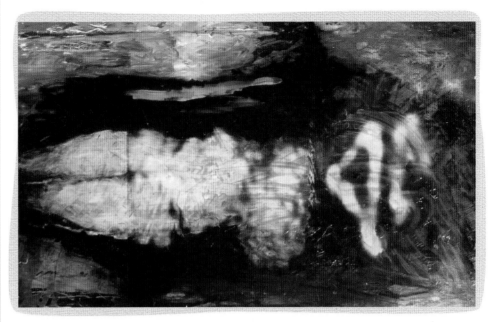

Notch Gene Figure Head
painting on computer-enhanced image

Workshop Notes:

Sometimes Newdoll uses a darkroom technique to print an image onto a canvas using a product known as Liquid Light.* (See sidebar p.105) This is a messy process, but the results are often interesting. You can use this process to create an exact replica of your image or just a suggestion of it. Use a photograph, slide, or negative you want to print onto a canvas or paper. Wear rubber gloves. The canvas can be prepared in advance. Paint it with an oil-based pre-coat and allow it to dry.

Newdoll also scans in or creates an image on her computer screen and looks at it to paint as if it were a still life. When painting, she plays the same music over and over to keep her mood consistent. A recent project, shown on the next page, took her from Berkeley, California to the Czech Republic. Draw inspiration from its inventiveness, and always remember that your own artistic passion can take you further than you ever envisioned.

Julie Newdoll

Greek Tragedy Through Necrobiology
Finally, the cloth for the garments of the characters
was stamped with the cell stamps and acrylic paint.

**"Art upsets, science
reassures,"
–George Braque.**

The study of the science of the
birth, life, and death of cells,
(necrobiology), stole Newdoll's
imagination: she realized that dif-
ferent types of cells are reminis-
cent of characters in a tragic play;
they commit suicide, are some-
times murdered or fated to die.
Following this thread, Newdoll
planned a painting portraying
four central figures in Greek
mythology who relate to cell life.

The figures were painted in warm
colors using very little or no turpentine.
Glazes added an additional veil of warmth.

The painting project grew to encompass a series of twelve works projected during a performance of a Greek tragedy at the Hermit Foundation in Plasy, Czech Republic.

The creation of the painting was complex: With linoleum carving tools, Newdoll engraved symbols representing the four stages of the cycle of a cell into rubber stamps (pictured in a bar on the previous pages). She used friends as models to make figure drawings, and incorporated "cell prints" (from the rubber stamps) into the painting, even adding additional cell stamps after she finished the painting.

In all, the project took three months to complete. As Newdoll says, it is a big story to tell, "Jumping genes, mutations, lead to a miracle. Cut one side and it fixes on the other. Proteins take on a shape that form these incredible three-dimensional shapes." This is her version of abstraction. A fusion of science and art. Perhaps it will inspire you to create a version of your own.

The Hermit Foundation in the Czech Republic invites artists from all over the world to install exhibitions in the historic monument of Plasy Monastery.

Woman Bound to DNA II
made with Liquid Light
36" x 48"
(91 cms x 122 cms)

Printing Images on Canvas

Heat the Liquid Light* gel by plunging the sealed container into hot water. Create a solution of five ounces of Liquid Light diluted with one to two ounces of Dektol developer. (Work in yellow, dark amber, or red light.) Brush or sponge on the canvas to coat.

In a darkroom, project the image onto this coated surface with an enlarger or a slide projector. Tape a black paper with a 1/8" hole in the center over the lens cap to limit the light output. Expose for about twenty seconds.

Develop the canvas in a tray—or by sponging on a developing solution. Newdoll smears on developing solution with a turkey baster for a gloppy effect. Be playful. Take risks. Be outrageous.

For large surfaces, even out the development by first wetting the emulsion surface with cool water.

Use two consecutive hardening fixer baths. This neutralizes the developer. The first bath is used only for a few seconds, the next for ten minutes. Use a powdered fixer for best results. Rinse the canvas under running water for ten minutes. Once the print is dry, you can use a warm iron or mounting press to flatten out any wrinkles.

*If this brand is not available in your area, a local photo supplier can suggest a good substitute.

Wishes

Parades, Travel, Sunrises, Sunsets, Painting, Flowers, Sunrises, Sunsets, Painting, Flowers, Family, Artists, Airports, Parades, Travel, Family, Artists, Airports, Symbols, Art Supplies, Stuff, Museums, Art Books, Presents, Artists, Workshops, Gardens, Being, Doing, Self, Love, Life, Workshops, Gardens, Being, Doing, Symbols, Art Supplies, Stuff, Museums, Art Books, Presents, Artists,

Express Yourself

You are your art

"I am not a human being. I am dynamite." – Friedrich Nietzsche

"Art is the most frenzied orgy man is capable of." – Jean Dubuffet

"Otherwise one would profane one's own powerful solution." – Wassily Kandinsky

"When the individuality of the artist begins to express itself, what the artist gains in the way of liberty he loses in the way of order." – Pablo Picasso

"I've found that every time I have made a radical change, it's helped me feel buoyant as an artist." – David Bowie

"Painting is easy when you don't know how, but very difficult when you do." – Edgar Degas

"Doubts must be resolved alone within the soul.

Airport →
Leave "Your "Ism's Home!
→
→

Museums are my libraries.
I read art.

You Art, We Art, Our Art

Thank you for joining me on the **creative journey**. If we do not express ourselves, who can do it for us? Reach, stretch, and examine who we really are and where we want to be. Where do we want to go with our **creativity**. Know that it is healthy to express yourself. It is essential to spirit, body, aura, essence. Assert yourself in every way. Shout! Laugh! Dance! **Dream!** Sing! Paint what you feel! Bring your total life experience to the easel, the museum, or gallery.

Have sketch book,
will travel.

Your work is you. **Who can be your critic?**

Who can say that what you produce is not remarkable? You are remarkable. Choose to try—to bridge the unknown and to jump over it.

I read you.

The Golden Ratio is a proportion found in native materials such as sunflowers, seeds, and dandelions.
You are golden.

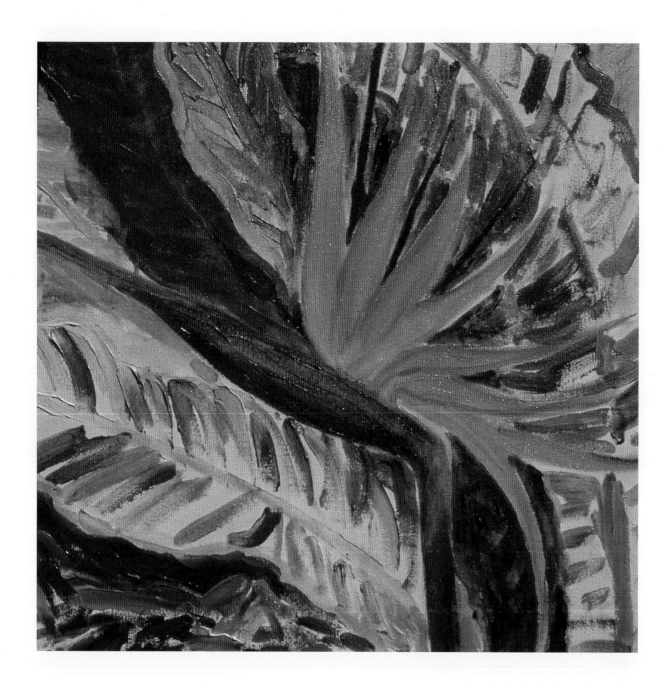

Bird of Paradise
acrylic
20" x 20"
(51 cms x 51 cms)

Lynn Loscutoff

"Can we ever be more fulfilled than by experiencing

the beauty and mystery of what has been so masterfully created in our universe?"

— Lynn Loscutoff

Lynn Loscutoff

Follow Your Creativity

This last workshop is on following your bliss, a must for getting creativity to flow. Are you following your bliss? Painting and traveling is my passion. Painting orchids in their natural environment has sent me on wild missions: Painting in the footsteps of the great artists who have gone before has inspired me to travel many miles. When I return, my studio is always a welcome retreat. My painting studio in Gloucester, Massachusetts took forty five years to happen for me. A funky old building, built as a studio in 1930, it represents my taking myself seriously as an artist. It is also a place to regroup in private and make decisions. Painting is about finding solutions.

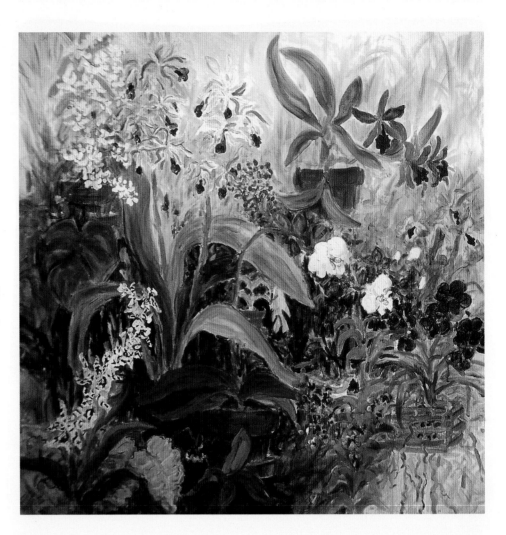

Falling in Love with Orchids
acrylic
48" x 48"
(122 cms x 122 cms)

A life-threatening illness gave me new insights. In my hospital room, I had time to really examine and understand each flower in a beautiful basket. I had always painted landscapes and crowds and never studied flowers before. I came to terms with my own mortality, learning from those sensitive shapes and colors and what they represented. I decided that I, too, could be perennial. I was part of the same natural system. Later, I planted a perennial garden around my studio. I became interested in all flowers, and especially those growing in their natural habitat. Spending time in Florida gave me even more new material—tropical plants and landscapes, orchids and bromeliads.

A favorite corner of my painting studio in Gloucester, Massachusetts, with a collection of paintings that are prospective candidates for collage or experiments.

The thrill of painting in the footsteps of a master certainly provides inspiration. Painting in the footprints of Van Gogh in the courtyard of the institution in Saint Rémy

Hike through the rain forest.

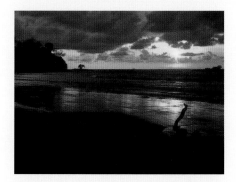

The sunset in Costa Rica—once again light, shadows, and the colors of night and day refresh. Always different. Always renewing.

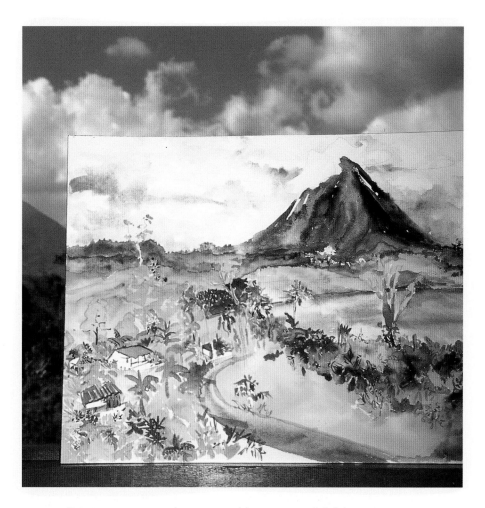

Painting an active volcano is a wild experience. I did this painting on cold press paper with my tiny traveling watercolor paint set.

Workshop Notes:

Pursue your interests. What gives you more inspiration than something that has already captured your imagination? What you bring to the easel is your past, present, and future. Make that future reflect your strongest emotions and desires. Try painting where the terrain is wild. You can make your studio wherever you are. Traveling and painting can create a breakthrough, as they have for me. Leave responsibilities behind and focus on what you see and feel. This is true for everyone—what you gain depends on the thoughts you take with you. Enthusiasm and openness are essential, but don't forget your paints.

Lynn Loscutoff

Follow Your Creativity

It's always hard to decide how much time to just look, and how much time to paint.

Change becomes me.

My fascination with painting orchids and bromeliads in their natural habitat took me (with friends) to Costa Rica. Whether you are going on a trip or just out the front door, keep your sketchbook always at your side and you will find something new to see.

A butterfly on a ginger plant inspired this painting, made on a trip to Costa Rica. In addition to painting outside, and working quickly to capture the mood, it was a challenge to use acrylic paints in a tropical climate. Acrylics offer wonderful painting flexibility, although it is difficult to control the quick drying time in a warm climate. Having used oils on many painting voyages, I welcomed the chance to add a new element with acrylic.

Try painting where the terrain is wild

A butterfly provides inspiration.

I start with a drawing (an 'S' curve structure). Try using acrylics like watercolors, as I have, by adding lots of water mixed with a few drops of flow release.

I paint the sky with cerulean blue, then define some of the shapes. Aureolin yellow works well to keep the shapes of the leaves. This very transparent color can be worked over easily, yet it produces "a record of the sun." The painting surface is hot press paper, a nice smooth surface that does not need toning. With watercolor or with watered acrylics the colors are not absorbed and remain vivid.

I quickly re-work leaves with shades of green. The palette also shows lots of magenta and cadmium red. Try painting over a single area of focus, as I did here with the ginger, to create a transparent glaze. When working on location, it is always good to stop and look again later, out of the sun and without all of the distractions. (In this case, birds and monkeys were chattering nearby. What a temptation.)

Last, before you embark on a painting, or consider a finished work with a critical eye back in your studio, think about all that makes up your personality, your psyche. That is what you bring to your easel. All of who you are and who you hope to be. Could there be more? Your story is still being written.

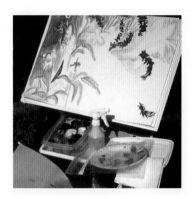

I couldn't resist gesturing in some of the Ginger shapes.

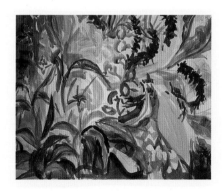

Experiment with colors. Buying colors in small tubes offers opportunities to play and test a new palette.

Tips For Traveling Painters

My "Art to Go" approach comes from a lifetime of travel (I eventually wrote two books on the subject.) Besides a small palette of paints, my setup includes:

- A spray water bottle to keep paints and painting moist
- Folding hat for the sun
- Light weight folding easel and chair
- A block of hot press paper
- Plastic plates for throw away palettes
- A collapsible water container

Tubes of paint are sometimes a problem at airports. Try squeezing acrylic paints into small jars. It is easy to spray moisture into the jars, and handy to have access from the open top for scooping paint or for keeping it wet. I keep all jars in a plastic-covered container. Another important piece of travel equipment is an umbrella that attaches to your easel: Shade is vital for you and your work.

If you can't paint all that tempts you on a trip, bring back plenty of good photographs. I use photographs to paint, laser copy, emboss on a print, or just enjoy a memory later at home. Save all those photographs and slides. They may be the start for any number of art pieces.

Shade is vital for you and your work

Lynn Loscutoff

Follow Your Creativity

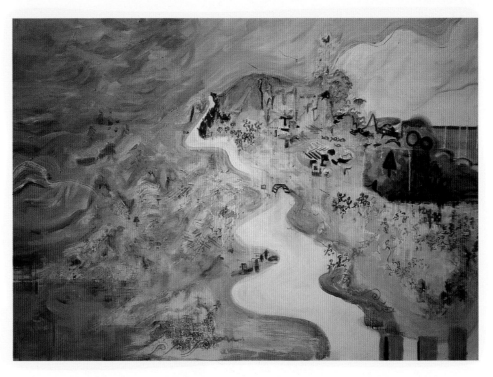

Visualization. During a time of recovery, this painting represented my healing: The river needed to be jumped over and the mountain needed to be climbed. Art works inside as well as out.

Visualization, Journals, and Collage: The Hand that Makes the Line Has More to Tell Us.

Like other artist seekers, I am convinced that we have a "spiritual DNA"—a natural gift of talent—and that we must give it voice. The hearts desires we had as children want to express themselves. Accept and embrace your talent; get reacquainted with both sides of the brain; keep a calendar of "artistic appointments" with yourself; finish unfinished projects and unharness potential.

Our wonderful computer brain has two points of view. The right brain is the intuitive, imaginative, emotionally expressive, innovative, and creative side. When we are painting, daydreaming, meditating, we are often in an "Alpha" state of consciousness and in our right brain. Your left brain dictates language function, analyzes and schedules time, and may be critical of what the opposite side of the brain is doing.

Often when you paint, and really focus on the painting, you have a different reality consisting of a symbolic world of colors, shapes, and contours. When you finish and stand back to examine your accomplishment, the critical side of the brain does the evaluating. We are often very hard on ourselves and have doubts about our abilities. The left brain and the right brain often disagree. A method to join the thinking of these two hemispheres is to become less critical and gain insight by keeping a journal dialogue with the non-dominant hand and the dominant hand. Write in a very large notebook with big crayons or pencils and have a good discussion. Try to write and draw in the journal every day. It is a remarkable way to really get to know yourself and to reframe your talents. This method also copes with self-criticism and doubt and gives you a boost of creative energy.

Make a collage of your "life's design". Give yourself a time line. One year, five years, tomorrow. Put this collage where you will see it everyday and believe your message.

A tropical tree by Rachael Randall, age nine. Give a child the materials and the freedom to express themselves and they can become the artist that the child in us remembers.

Still life by Rachael Randall. She painted six canvases while I was looking for the beach equipment.

My interest in symbols prompted these paintings, part of a diptych, designed to hang in a corner.

Artists are visual beings. We now know that visualization makes a real impact on our brain. We can visualize ourselves thin, healed, winning races, becoming successful.

To take visualizing a step further, make a collage for your "life's design," of your hopes and dreams and your talents. If you want to sell your talents suggest this in your collage. Cut out motivational captions and sayings from magazines; find pictures, paintings, and photographs of what you desire to happen in your life, especially in your life as an artist. Give yourself permission. Get outrageous. Get imaginative. Dream your desires. Whatever you would like to achieve can be yours. How do you know? Because you have a picture collage of it already happening.

*Note: This section is based on the work of author Lucia Capacchione, author of *The Power of Your Other Hand.* Her workshop on the importance of journals inspired me.

Picture This

Art comes from within, but there are interesting ideas, fascinating themes, and layers of tradition all around us. What follows is my own collection, a kind of "pictionary" of signs, symbols, and useful thoughts on art.

Light

Light evokes images of reverence. Sunlight (often worshipped) fuels the earth and all living creatures. Wavelengths of light stimulate us. Nothing in painting would exist without light.

Circles - white for life; black for death

Circle of Life - the snake eating its tail represents the circle or cycle of life of alchemists.

> "All matter is frozen light"
> —David Bohm, physicist

Eyes - light nourishes our body through our eyes. Our sense of sight is the most dramatic use of our eyes. Those 130 million photoreceptors called rods and 7 million cones that function mainly in daylight are concerned with visual acuity and color discrimination. These photoreceptors transform light into electrical impulses that are sent to the brain to construct visual images and affect our vital functions.

LOOK for reverberations

Front light - move objects on a surface to observe that shadows describe the subjects they are cast upon. Front light and casting light bounce in the shadow.

Light walks - look for reverberations as light reflects off surfaces. Take "light walks." Study light striking objects and landscapes and making patterns on earth and in the sky. Spend at least one hour a day in the sun.

Source light - one source light illuminates one area of an object and casts a shadow to anchor the object to a surface. In this instance the light is from the back.

Prism - in 1672, Isaac Newton discovered that light passing through a prism consists of the colors of the rainbow (visible spectrum) and when entering back into a second prism becomes white again.

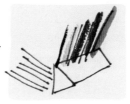

Plein Air Painting - according to Dr. John Ott, a pioneer in the field of photobiology, full-spectrum light is the ignition system for all biological functions. He believes that light is the medicine of the future, and that, for example, ultraviolet light through the eyes strengthens the immune system. His studies show that it is imperative to our health to live in the light.

Refraction - Ptolemy, a second-century astronomer, discovered that light bends at the boundary between two media of dissimilar nature, creating refraction. As light passes through the atmosphere, air, water, or glass, its rays bend. For a painter, the greater the refraction, the greater the opacity. Pigment suspended in a solution equals paint.

Sun - this is one of the oldest Western ideograms, it appears in many cultural spheres. It means sun or hydrogen or the gold of alchemy. In astrology, it represents the "creative spark of the divine consciousness that exists in every individual." In cabalistic mysticism, the archangel Michael is related to the sun and the day of the sun, Sunday.

Sunlight - thousands of years ago, Druids built temples to the sun. Much later alchemists sought gold as the elixir of eternal life called the "Sun of Matter." They believed the elixir would cure all ills and rejuvenate humans into an incorruptible "body of light."

Movements in Light Painting

There have been three broad movements of light in painting: Tonalism—concentrates on color and color schemes. Within these colors, value is assigned according to the degree of lightness or darkness. In tonalism, the choice of color and the resulting palette is one of the most important facets of the art.

Impressionism—characterized chiefly by short brush strokes of warm colors in immediate juxtaposition to cool or complementary colors. Impressionism concentrates on the effects of light on objects.

Realism—distinguishes the actual components of a picture and relies heavily on the treatment of form, color, and space in such a manner as to emphasize the actual visual experience.

Vision and Neurolinguistic Programming (NPL)

NPL is based on the observation that eye movements trigger certain types of sensory recall. Notice how people move their eyes in order to remember information. Stimulus that is visual, auditory, kinesthetic, constructive, or remembered will lead people to look in a particular direction before answering a question. Experiment with this yourself. Our wonderful eyes are sensory filters of consciousness to our brain, as well as transmitters of beautiful images to paint.

Picture This

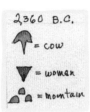

Line and language

Storytelling marks began to give written expression in the form of language in Ancient Mesopotamia in the 3rd Millennium BC. Commerce necessitated the first tablets, found with geometric designs used for counting.

Chinese symbols have remained the same for two thousand years. Cuneiform inscriptions found on monuments date from 1900 BC. While cuneiform signs were spreading through Mesopotamia, other writing systems were developing in Egypt and China. Writing was considered a divine gift. Early Greek symbols remain undeciphered. Egyptian Hieroglyphs, "writing of the gods", conveyed abstract, as well as concrete, ideas. Pictograms dating from 2360 BC have been found near ancient Babylon. The Rebus was a significant step in the progress of writing, occurred when pictograms were made to represent sounds, the simplest form of phonetic use.

Line is the grammar of art—a path made by a pointed instrument: a pen, a pencil, a crayon, a stick. It implies action. It suggest direction or orientation. An effect of movement can be achieved by a series of linear shapes. Line is alive with meaning. Line is the universal experience of writing and drawing. It can be precise; it commits the artist to a specific statement; it exists as real or implied; it leads the eye into a destiny.

Alberti, Leon Battista - suggested that the roots of art are in the mechanism of projection in the mind, that certain contours suggest a shape from nature and that viewers—through either adding or subtracting—sought to make a perfect likeness, even when there was no vague outline to suggest the form.

Calder, Alexander - drew with lines in three dimensional sculptures and mobiles.

Cross - the most commonly used design element is the cruciform.

da Vinci, Leonardo - studied the human form when still and in action, using diagrams of lines in a circle. He based his findings on Golden proportions found in the human body. Line can lead you on a path of discovery.

Diagonal - lines dance together and create a strong force.

Horizon line - an important line for artists; used to judge perspective, select placement, plan landscapes, and create tension.

Klee, Paul - "Line describes the shape of things, and calls attention to the making of them with a type of metaphysical wit. He makes linear illusions deceiving reality."

Matisse - represented swelling curves of thick and thin lines on his figures and ornamental arabesque lines in his interior designs.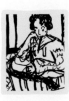

Golden Ratio

The ancient Greeks believed that proportion in art and in life led to health and beauty. A ratio developed by Euclid in 300 BC. formed the basis for Greek art and architecture and governed the design of the Parthenon in Athens. Named the "Golden Ratio", or "Golden Section," it was thought to embody the perfection of God's creation. For centuries, it has provided artists with a division of space that gives harmonious proportions. Several intersections can be created with this same principal to give strong divisions for dramatic placement. To create this perfect shape requires at least four stages: (see drawings p.24)

First Stage: Make a line from A to B (AB) and find the mid-point (C). Then draw a line up from B at a right angle. The length of this line should be equal to the distance from C to B (BC). The end of this line is point D (BD).

Second Stage: Now draw a line to join A and D. Then measure along AD from D the same distance as BD, and mark a point (E). The distances BC, BD and DE will be equal.

Third Stage: Next measure the distance AE and mark point AB at the same distance from A. The distance AE and AF will be equal.

Fourth Stage: Drop lines down at right angles from A, F and B. On the lines from the points (G and H). These will mark the bottom corners of your rectangle. Measure the distance FB on the lines. AG and BH will give the "Golden Section" where this crosses the line FI.

Fifth Stage (if you choose): A rectangle whose sides are in the Golden Ratio can be divided into a square, plus a Golden rectangle. This rectangle can also be divided into a square and a rectangle and so on ad infinitum.

As old as this theory is, it is new every time you apply it.

Mondrian - made intellectual order with his vertical and horizontal lines, as he reintroduced the "Golden Ratio" principles.

Parallel - side by side, longer and shorter. Parallel lines create balance.

Perception - a process in which the next phase of what will appear when we test our interpretation is all but anticipated. Mosaic artists know how to create eye teasers with ambiguities. A stained glass window is created with various shapes of glass, none of which, when separated from the whole, represent the image.

Perspective - a method of constructing images designed to create illusion, to deceive the eye.

Picasso - used the power of underlying geometric forms to strengthen his work.

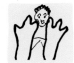

Pressure of line - can describe volume of form, or bring objects closer.

'S' curve - one of the best, real or implied, lines for composition

Shapes - change in relationship to each other. Move them in space.

Weight - of line, texture, and placement add illusion. All lines relate to each other. Opposing lines give tension.

Variation - in size indicates position in space.

Primary Colors

The search for what is primary and what is secondary color evades all classification. How many primary colors are there? There are currently three schools of contemporary theory. The additive school contends that red, green, and violet are primary. The subtractive school chooses bluish-red, yellow, and cyan. The perceptual school adopts red, green, yellow, and blue. In 1704 Sir Isaac Newton based his theory on seven primaries. A. H. Munsell, one of this century's most prominent theorists determined there were five. Wassily Kandinsky's painting and teaching exercises are based on six primaries. Paul Klee and Johannes Itten adhered to a system based on five. The conclusion is that there is no conclusion.

"Color deceives continuously."
—Josef Albers

Color lies between intuition and emotion: Color bridges the conscious and the subconscious world. Color is the primordial way to convey human hopes and fears.

Abstract colors - insinuate an image or idea rather than using realistic forms.

Analogous colors - contiguous on the color wheel. They are harmonious with each other and are related. They mix well together.

Arbitrary color - is used by Fauve Artists. Color is chosen in any manner the artist chooses without regard to a formula.

Auras - the color spectrums emanating from people and objects. Some people are able to see them. Others claim that they can tell our state of mind and our health condition by aura color.

Chakras - Sanskrit writings describe the body as having seven major energy centers known as chakras. Each responds to a different color.

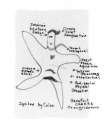

Chevreuil - "Every hue throughout your work is altered by every touch that you add in another place. Warm colors come forward. Cool colors recede."

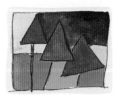

Color therapy - Pythagoras, Greek philosopher, used color therapy in 500 B.C.

Color theory - is in flux. There have been more than fifteen color wheels in recent history.

Complementary colors - opposites on the color wheel. The presence of one denotes the absence of the other. Red is the complement of green. Red is the afterimage of green and green is the afterimage of red. Mixed, they make a neutral.

Contemporary art - there is renewed interest in the critical spatial effects of color. Contemporary artists are working with neon and "Day-glo" colors and pigments to discover new chromatic effects.

Fauvists - used flat areas of brilliant hues to create vibrant effects.

Halation - originated from the art of photography, it refers to the blurred effect at the edge of a photo near very light areas. In painting, two colors placed next to each other to form an aura or a halo.

Harmonious color - defined by Leon Battista Alberti, an Italian architect in the fifteenth century: "I shall define beauty to be harmony in all parts, in whatsoever subject it appears fitted together, with such proportion and connection, that nothing can be added or diminished, or altered, but for the worse."

Hues - mixtures that result in orange, green, and violet. The most intense hues are achieved by mixing.

Illusion - causes the brain and eye to create an image or idea from a collection of shapes and colors.

Intensity - purity of color and the implied absence of a visible color mixture.

Jung, Carl - "Color expresses the main psychic functions of man."

Kandinsky - searched for a grammar of color analogous to music, and, later in his career, tried to rid color of any symbolic associative elements.

Local color - the color we know an object is supposed to be.

Monochromatic color - exclusive use of one color. Often associated with black or white, it can include a range of any single color. Probably one of the first notable examples, is Kasimir Malevich's *White on White*.

Reflectance and Full-Color Images

In 1950, Edwin Land (inventor of the Polaroid Land Camera) accidentally discovered that exposure made from one long wavelength and one short wavelength could be used to create a full-color scene. These colors were not primary colors. In a classic demonstration, a black-and-white transparency was projected on a screen and a red filter was added. Instead of a pink image, a full-color image was seen. The eye and brain are able to see full images of color independently of wavelengths of light. Land's theory is called Retinex. Retinex explains why colors are affected by surrounding colors. Shadings affect accuracy, which calculates reflectance. As the "eye" within the brain looks on different images, cross-compared reflectance images in the world of hues are created. Brightness changes as energy returned from a surface. Color is determined by a value called reflectance. Reflectance is the degree to which a substance reflects light. The visual system is able to infer reflectance by analizing brightness, due to the cellular interaction of the visual cortex and the retina. Our world of color is marked with unique combinations of reflectance.

Picture This

Medium - Colors act differently in different paint mediums. Here, two different mediums make a neutral.

Optical mixing - Impressionists, Pointillists, and Neo-Impressionists used optical mixing (the mixing of color by the eye) to play with dots and colored patches and create an overall structure of reality.

Physiology - viewing red for a long period of time can increase your blood pressure. Pulse rate and respiration decrease under black. Red light can give an athlete a burst of energy. Blue seems to relax people and relieve stress.

Polarity - Isaac Newton (1666) studied the color effects on primary polarity and determined that yellow advances and blue recedes.

Synesthesia - "color thinkers" or people who see color as well as sound. For them, hues may be associated with lines, figures, letters, numbers, and words.

Tonality - overall color effect of a work that imposes a color unity.

Value - lightness or darkness of a color. In the example, as white is added, the red color becomes higher in value until pure white is reached. If black, or another color that has a darkening effect is added, the value becomes lower.

Vision - a single amino acid, the minimum genetic difference between two people, can cause a perceptible difference in color vision. Some theories suggest color preference is part of primal memory. Different wavelengths or colors of radiation may interact with the endocrine system to stimulate or inhibit hormonal production.

Picture Red

brilliant, intense, opaque, dry, hot, heat, blood, danger, passionate, exciting, fervid, active, intense, rage, rapacity, fierceness.

- Red is the longest wavelength from the sun: 650 to 700 nanometers (billionths of a meter).

- Red is the most energizing of all the colors.

- Red is the first color of the sunrise and the sunset.

- Red signifies passion, strength, royal attributes, and sexual powers.

- A red environment makes one excited; red elevates mood.

- Red is a pigment as well as a primary.

- Red's presence in prehistoric cave paintings, along with black and white, make it one of the oldest colors used by humans.

- Red is a signaling, attention-getting color and is universally used for stop signs or warning lights

- Red photo pigments, a type of protein, affects the part of the cone cell in your eye where color perception begins, studies show that there are infinite numbers of ways to see red.

- In a recent study, viewing a red light increased strength for athletes.

- Red represents the seventh chakra, or the root.

The rods of the retina are less sensitive to red. A red light at night allows rudimentary cone vision without changing the state of dark adaptation.

Picture Blue

transparent, wet, cold, sky, water, ice, subduing, melancholy, contemplative, sober, gloom, fearfulness, furtiveness.

"Blue is the only color which maintains its own character in all its tones."
—Raoul Dufy

Blue is calming and rejuvenating along with violet and indigo, the colors of night.

Blue is a primary of both pigment and light.

Blue is a color that can rarely be reproduced in nature.

Blue is so representative of the sky, it has been associated with spiritualism, wisdom, and the afterlife.

Blue is most often chosen as a favorite color.

Blue is a retreating color. Some psychologists suggest that it is the color of deliberation, introspection, conservatism, and acceptance of responsibility.

Painters and designers know that blue can create a sense of depth.

Kandinsky suggests that blue in a spiraling circle turns in on itself.

Blue light is being used with athletes to assist in a more steady energy output.

Blue represents the second chakra, the eye; sky blue represents the sky.

Picture Green

clear, moist, cool, nature, quieting, refreshing, peaceful, nascent, ghastliness, disease, terror, guilt, jealous, nauseating, rich, lush.

- Green takes over, if you are not careful.

- Green covers 80 percent of the earth.

- Green is the color of photosynthesis.

- Green is the absence of red and the presence of yellow and blue.

- Green food is essential for us to eat to stay healthy.

- Green is the neutral color of the visible spectrum.

- Green used as an environmental color is restful and has healing properties.

- Green is the center of the visible spectrum and represents life graced with health and balance.

- Green represents youth and growth.

- Green represents the heart chakra.

Picture Yellow

incandescent, radiant, caution, cheerful, inspiring, vital, celestial, high spirit, health, intellectual, glowing, cowardly, yellowing with age.

- Yellow is sunny. It greets us each day with the sunrise.

- Yellow is a warm color.

- Yellow comes forward in a painting.

- Yellow mixes with blue to make green.

- Representative of the solar plexus chakra.

- Yellow is energizing and exciting.

Picture Orange

bright, luminous, glowing, warm, metallic, autumnal, jovial, lively, energetic, forceful, hilarity, exuberance, satiety, social.

- Orange is a sun color.

- Orange is a secondary color.

- Orange is the complement of blue.

- Orange represents the sixth chakra, over the spleen.

Picture Violet

deep, soft, atmospheric, cool, mist, darkness, shadow, dignified, pompous, mournful, mystic, loneliness, desperation.

- Violet designates royalty.

- Violet represents the first chakra, the head or crown.

Picture White

- [] White is the total of all complementary colors.

- [] The Chinese believe that using white and black represents all color.

- [] White paper or canvas is the artist's challenge.

- [] Buy lots of tubes of white, no matter what your medium: it cannot be mixed.

- [] When used with great intensity white can give a high-key effect to art work.

Picture Black

- [x] Black is mysterious.

- [x] Black makes wonderful lines for accents.

- [x] Black is the opposite of white.

- [x] Black is the absence of all color.

- [x] Black gives drama to paintings, drawings, and illustrations.

- [x] Black permanent ink can be an artist's best friend.

- [x] Many artists never use black paint out of a tube, but mix combinations of other colors to create more depth and illusion

Dessert

Wayne Thiebaud
Coloring our Creative
Appetites

I relate to Wayne Thiebaud's images. As a native San Franciscan myself, I get the same thrill looking at the wild angles and distorted perceptive in his cityscapes as I got as a child whipping down those same hills on roller skates. I have followed his exhibitions, read every book that discussed his works, studied his methods, and have considered him my teacher. I spoke with him in his studio at the University of California, at Davis and share this "private workshop" with you....

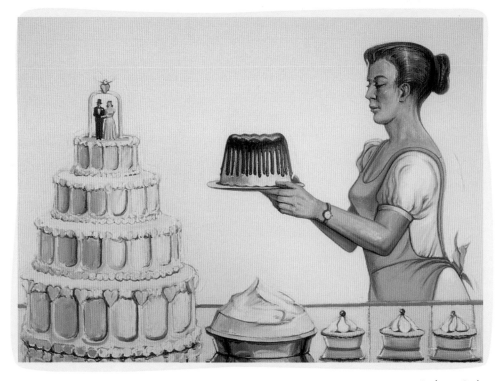

Bakery Girl,
oil on linen
37" x 43"
(68 cms x 74 cms)
Wayne Thiebaud

"I am interested in foods that have been fooled with and decorated." Thiebaud enjoys the ceremony of food. He refers to these as "tattle tale" signs of our culture: Ritualistic experiences of gastronomic festive delights.

"To me painting is more important than art. None of us know what art is. It is an abstraction. It is non-concrete. It is a discourse. In other words, it

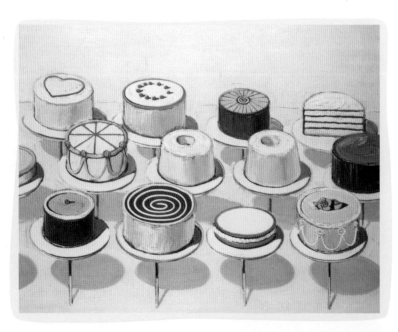

Cakes
oil on canvas
60" x 72"
(152 cms x 183 cms)
Wayne Thiebaud

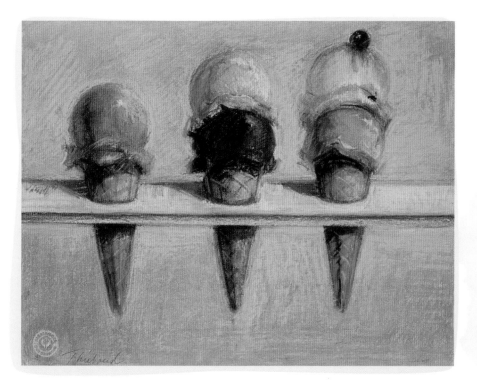

Three Ice Cream Cones,
pastel on paper
Wayne Thiebaud

On Teaching Students

"Teaching has meant a lot to me. Teaching has been very central to my life. But, I don't see it as being very different than being a painter, in a way. Trying to set problems, trying to understand problems, trying to push on through. Challenge yourself and get to those questions that we often find have not been answered. Students remind you that those questions have not been answered. They'll ask them out of innocence, but those are still questions that we need to address and change our attitude about. I tell my students that painting is more important than art. When they say, I am going to make some art now, I tell them, wait a minute, you are going to make a painting, but someone else is going to decide whether you are doing art. I enjoy painting because of its self-educating process. In some ways it's audacious for any of us to pick up a brush. But, it is still wonderful to be attracted to that community of what painting and drawing has been about."

has to do with verbal construction. You never can prove it. Everybody has a different idea about it, even though there can be a confluence or consensus. Art is this sort of wonderful thing we pay so much attention to, but it is something for painters not to have to worry about, because when they do a painting, something that is very specifically concrete, it is absolutely, unequivocally there and all ranges of it can be pleasurable. It is something that you can feel vibrations from. It is a metaphor of the body. It is a human tract. The range of the character of a painting is infinite, endless."

Picasso said, "I have never seen a painting that I couldn't be interested in. Even when I go to a little motel and see someone painting a little pink poodle. I know how difficult it is to get that bunch of chemicals translated to a surface without embarrassing your self beyond belief."

"You think you are in charge of the painting and then you find out that it is in charge of you. The fun is the unpredictability. If you have painted a painting that bores people, you have shirked your responsibility."

Thiebaud tries not to be subjective in his portrait or figure paintings. He is interested in the physical state of being.

Dessert

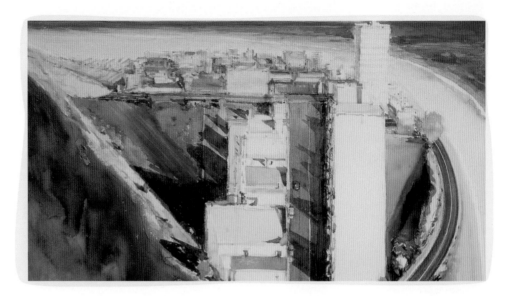

Ocean City
watercolor and charcoal on paper
22" x 31"
(43 cms x 62 cms)
Wayne Thiebaud

Halation refers to the aura, halo, or hazy color around the edge of a subject; or vibratons of two colors next to each other.

Regarding Halation:

"I work with my students to understand that there are two ways of rendering light. To understand that color has its own form, that the process of determining form, space, light, and structure is apart from value structure as in black and white or dark and light. Halation is a pretty simple human trait. Test it for yourself sometime. Take a strong light, or even better, go outside. Put the light fairly close to an object and stare until the two views begin to oscillate. They begin to vibrate because the eye will hold its position for a long time. But, because you are seeing two images, stereoscopically, they are never quite perfectly fused. That is how you get halos, or auras.

You don't try to necessarily imitate this [in a painting], even though it can be imitated. What you want to do is translate it into some kind of a message. You try to figure out ways or some convention that stands as metaphor of this idea. As in Matisse (using the Law of Simultaneous Contrast): when two colors of equal intensity are put next to each other they will fight for spatial dominance so that you get a vibration.

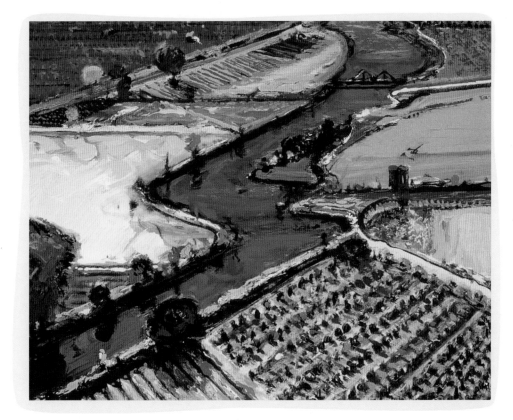

Brown River
oil on canvas
16" x 20" (41cms x 51 cms)
Wayne Thiebaud

But the form, the value structure, is always the primary concern with its value configuration which created the composition. You try to imitate the transition of light on objects. You watch and see where the shadow core is. Where the reflective light is and you very carefully annotate that so that you make a kind of structure based on the quality of light as it is transcribed in terms of its form.

Coloristically, you can't do that. If you put an orange down where you would like it to be. The orange, in terms of the color structure, will come further forward or recede. But you can create a feeling of light by contrasting character, so space and the light are created in terms of color energy and not by the creation of light on form. Those two things are very different, but you can also combine them. Degas and Matisse were trying to do that. There was a kind of merging of the Eastern and Western tradition. And that is a little bit of what I am trying to do as well."

Contributors

Rachel Kennedy
Line, page 25

Born in Nova Scotia, Kennedy is a graduate of the Rhode Island School of Design and now resides in Naples, Florida. A prolific painter, she travels and paints along the East Coast and exhibits in galleries from Nova Scotia to Cape Cod to Florida. New England has influenced much of her series of drawings, paintings, and prints. This author has painted on location with Kennedy from the Florida Everglades to the Maine Coast, she is the most *à la prima* painter with the fastest brush I have ever witnessed (except for me).

Sylvia Edwards
workshop one, page 34

A graduate of the Museum School, Boston, Massachusetts, Sylvia Edwards travels have led her to the Mid-East. She now divides her time between London, England and Cape Cod, Massachusetts and Norwalk, Connecticut in the United States. Her travels have influenced her work, especially her work with UNICEF. Her limited edition prints, posters, and cards are distributed internationally. Her list of solo exhibitions reads like a map of the world. Her work is in countless public collections including the Tate Gallery in London, the National Museum for Women in the Arts in Washington, D.C. and the Museum of Fine Arts, Alexandria, Egypt.

Mary Todd Beam, AWS, DF, NWS
workshop two, page 40

Divides her time between Cambridge, Ohio and her Smoky Mountains studio in Cosby, Tennessee. Gold Medal winner, American Watercolor Society, workshop instructor for 25 years, and former elementary school instructor Beam is an enthusiastic member of the Society of Layerists, the Experimental Society, and is a sought-after workshop instructor. Pictured here at her Master Class workshop with author, Lynn Loscutoff at Bonclarken, North Carolina.

Maxine Masterfield, AWS
workshop three, page 46

A graduate of the Cleveland Institute of Art and a resident of Sarasota, Florida, Maxine is an active member of the American Watercolor Society, the Kentucky Watercolor Society, the Florida Watercolor Society, and is the founder of the International Society for Experimental Artists. She is the author of *Painting the Spirit of Nature* and *In Harmony With Nature*. Her video, *Painting With Maxine Masterfield*, is available as a teaching tool. She juries and conducts workshops throughout the United States – and especially enjoys teaching at her studio in Sarasota at the artists' colony of Towles Court.

Contributors

Louise Cadillac, AWS, RMNW
workshop four, page 52

A resident of Lakewood, Colorado, Cadillac has received a gold medal from the American Watercolor Society and was awarded the distinctive Vincent Van Gogh Plaque for outstanding leadership in art education. She conducts workshops internationally, and juries throughout the United States. Her instructive articles are published in such periodicals as *Watercolor; Water Media Workbook*; and *Artists Magazine*. Cadillac says, "Let it flow."

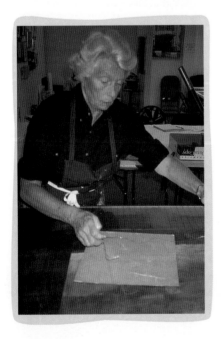

Joan Osborn Dunkle
workshop five, page 62

A Naples, Florida and North Hampton, New Hampshire commuter, Dunkle maintains two studios. A prolific workshop instructor and a coordinator of wildly creative workshops for the past 25 years, she is listed in "Who's Who in America", "Who's Who in The East" and is a member of the National Association of Women Artists. Her awards of distinction are numerous. She states that her art is intuitive, concerned with transformation of unpredictability of diverse materials.

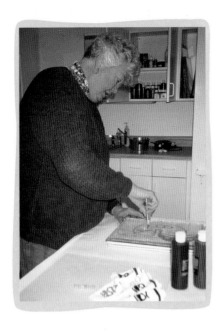

Nancy Marculewicz, B.F.A.
workshop six, page 70

Marculewicz was born in Great Neck, New York, grew up in Mystic, Connecticut and received an Associate's Degree in Liberal Arts from Bradford College in Haverhill, Massachusetts, and a B.F.A. from Rhode Island School of Design. She has taught at in the art department at Governor Dummer Academy and Endicott College in Massachusetts. She is a member of the Monotype Guild of New England and The North Shore Art Association. Marculewicz resides in Essex, Massachusetts. Her gelatin printing technique was inspired by her mentor, Francis S. Merritt. They are currently collaborating on a book about gelatin printing.

Rose Swisher
workshop seven, page 76

The Mendicino area of the California coastline provides Rose Swisher with the setting for much of her meditations and writings. Buddhist chanting gives her the quiet place that writers and artists so frequently find feeds inspiration. Swisher attended San Francisco State College and has traveled in New England, Africa, and California. Stamping with rubber stamps is a very social activity, as well as a great embellishment to paintings. Swisher's poetry and writings are a collected from her life's work and reminiscence. Swisher resides in Gualala, California.

Contributors

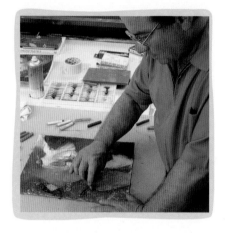

Rafa Fernandez
workshop eight, page 86

Fernandez was born in 1935 and is one of the most accomplished, honored, and recognized artists of Costa Rica. An artist of international acclaim, his work has received numerous awards; appeared in more than 100 exhibitions; and garnered appointments and national commissions throughout the world. He studied at the Casa del Artista in Costa Rica, and at l'Ecole des Beaux Arts in Nicaragua and the Cercle des Beaux Artes in Madrid. He taught at the school of Creative Stages of printing and lithography at the Beaux Arts University of Costa Rica. Fernandez mural work is esteemed, and his paintings appear in collections of museums in America and Europe.

Juan de la Cruz Machicado
workshop nine, page 94

Born in Puno, Peru, Machicado studied at the Regional School of Fine Arts "Diego Quispe Tito" in Cusco; at the School of Art in Lima; and studied painting at the National School of Fine Arts, Peru. His studio, Taller 24, is in Cusco. Machicado's paintings of Peruvian village life are exhibited internationally, appearing in Germany, Peru, Spain, Japan, Chile, Bolivia, Argentina, England, and the United States. His work is reproduced on posters to promote Peru worldwide through the government institution FOPTUR (the fund for the promotion of tourism), and for the benefit of UNICEF. Machicado's work has also been reproduced in tapestries, which were exhibited along with his paintings at the Organization of American States in Washington D.C.

Julie Newdoll, B.S., MA
workshop ten, page 100

Newdoll has excelled in art since the age of 14. She received her Bachelors Degree in Microbiology from the University of California at Santa Barbara, and her Masters Degree in Medical and Biological Illustration from the University of California at San Francisco. Newdoll worked in Scientific Visualization for seven years, using computer graphics as a tool. The Exploratorium in San Francisco contains an ongoing exhibition of her cell and music study. She works as computer animation and film supervisor of digital lighting for Tippett Studio in Berkeley, California. Newdoll recently completed an artist-in-residence program at Project Hermit, Plasy, Czech Republic.

Wayne Thiebaud
Dessert, page 130

Wayne Thiebaud was born in Mesa Arizona. His art career began early, with work as an illustrator and animator for Walt Disney. A professional painter for four decades, he has taught for many years and continues to maintain a studio at the University of California, Davis. He refers to his style as "object transference"; he is also known for the halos of "under drawn" layers of color that define many of his subjects.

Thiebaud's work is represented in the collections of the National Gallery of Art, the Metropolitan Museum of Art, the Whitney Museum of American Art, the Chicago Art Institute and the San Francisco Museum of Art. Celebrated as an artist, honored as a teacher, he is the subject of Karen Tsujimoto's book, *Wayne Thiebaud*, published for the San Francisco Museum of Modern Art.

Acknowledgments

This book was written with spontaneity and the joyful spirit of generosity and cooperation. My heartfelt thanks to each contributing artist is freely given and well-deserved. In the process of creating a force to inspire you, the reader, these Master Artists have inspired me to become even more daring. My husband, Jim, my children, Holly, Carol, and Jim, have kindly respected my time and space to enable me to focus on conveying what I sincerely feel as an artist. Shawna Mullen, my editor, has been encouraging, patient, and has invited me to a challenge that we both have shared. I am grateful to Rockport Publishers for allowing me to have fun and to be playful. And now, I am anxious to get back to my studio to experiment with all of these new possibilities, and take them even a step further – as I am certain you will, as well.

A special note of thanks to Wayne Thiebaud; I can never think of ice cream cones as just so many calories again.

About the Author

Lynn Leon Loscutoff is the author of *Art to Go, A Traveler's Guide to Painting in Watercolor* and *Art to Go, A Traveler's Guide to Painting in Oils.* A coast-to-coast commuter, an activist, and former art administrator at the Copley Society of Boston, Loscutoff is interested in all fine art mediums. Her work is shown at Prospero's Gallerie Eclectic in Naples, Florida; and at The Judi Rotenberg Gallery in Boston and The Acacia Gallery and State of the Arts Gallery in Gloucester, Massachusetts.

Loscutoff attended the University of Southern California, Los Angeles; Staley College, Boston; The Art Institute of Boston in France; and the Montserrat School of Art in Beverly, Massachusetts. She is listed in *Who's Who in Art Internationally*; *Who's Who in Art in America*; *Who's Who in the East*; and *Who's Who in Women Artists*, and is an active member of the National League of American Pen Women.

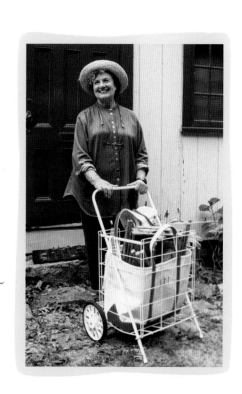

Dear Artists,

Please consider this book a synchronicity, a meaningful coincidence in time and space, an intuition for you to increase your artistic consciousness toward higher levels. Imagine this as an almost mystical journey, an acceleration of your creative ability—a beautiful reward to give yourself.

—Lynn